IMAGES
of America

FILIPINOS IN
HAWAI'I

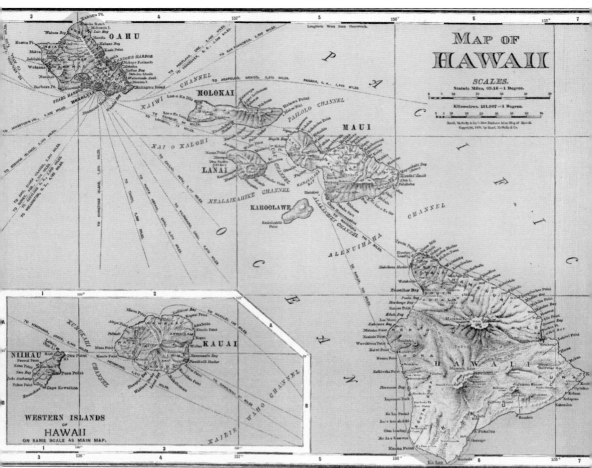

This map of Hawai'i was published in 1898—one year before the US-Philippine War and eight years before the formal importation of Filipino labor to the Hawaiian islands. (Courtesy of University of Hawai'i at Mānoa Hamilton Library, Map Collection.)

ON THE COVER: The Miranda family (pictured) was active in the Nawiliwili/Niumalu Tenants' Association in resisting evictions from Kanoa Estate land throughout the 1970s and 1980s on Kaua'i. (Courtesy of Ed Greevy.)

IMAGES
of America

FILIPINOS IN
HAWAI'I

Theodore S. Gonzalves and
Roderick N. Labrador

ARCADIA
PUBLISHING

Published by Arcadia Publishing
Charleston, South Carolina

Printed in the United States of America

Library of Congress Control Number: 2011925501

For all general information, please contact Arcadia Publishing:
Telephone 843-853-2070
Fax 843-853-0044
E-mail sales@arcadiapublishing.com
For customer service and orders:
Toll-Free 1-888-313-2665

Visit us on the Internet at www.arcadiapublishing.com

*Theo Gonzalves dedicates this book to Charita, who rapped with him
till the sun came up, and to Rudy, who is cooler than Santa Claus.*

Rod Labrador dedicates this book to Christine, sika ti silaw
a mamagrayray iti puso ken isipko, *and Miles and Ella,*
dakayo makaaramid ti naranraniag a masakbayan.

CONTENTS

ACKNOWLEDGMENTS

We are grateful for the encouragement from our partners in this project, such as the following: Patricia Brown and the officers of the Filipino American Historical Society of Hawai'i, Gina Vergara-Bautista of the Hawai'i State Archives, and Clement Bautista of the Filipino Digital Archives and History Center of Hawai'i (eFil). Special thanks go to Debbie Seracini, our diligent and patient editor at Arcadia Publishing.

The following provided invaluable assistance with access to their collections: Mary Requilman of the Kauai Historical Society; Nicole McMullen of the Maui Historical Society; Pixie Navas of the Kona Historical Society; Roslyn Lightfoot and Holly Buland of the Alexander and Baldwin Sugar Museum (Maui); Ross Togashi of the University of Hawai'i (UH) at Mānoa Hamilton Library's Maps, Aerials, and Geographic Information Systems; Jim Cartwright of the UH Mānoa Hawai'i War Records Depository; and Matt Kester of the Brigham Young University Hawai'i Joseph F. Smith Library's Archives and Special Collections. Many thanks to Joan Hori, Jodie Mattos, and Ann Rabinko of the UH Mānoa Hamilton Library Hawaiian Collection. Ed Greevy offered invaluable assistance by sharing his photographs and donating much-needed equipment.

Technical assistance and access to rare documents were offered by the following: Radiant Cordero of the *Fil-Am Courier*, Geminiano Q. Arre Jr. of the Filipino Community Center, Harry Wong III of Kumu Kahua Theatre, and Marty Myers of the UH Mānoa Kennedy Theatre Archives.

We are grateful for the support, stories, and photographs shared by Amy Agbayani, Leonard Andaya, Bernadette Baraquio, Joel Bradshaw, Ellen Rae Cachola, Stephanie Castillo, Kim Compoc, Greg Gardner, A.J. Halagao, Henri Hoogewoud, Abe Ignacio, "Kathy with a K," Niki Libarios, Ernest Libarios, Tim Llena, Domingo Los Baños, William McElligott, Pepi Nievas, Irma Peña, Wayland Quintero, Jerel Salviejo, Kenichi Takahashi, and Tasha Valenzuela.

INTRODUCTION

You could do worse than a partial view, not just in terms of a south-facing hotel suite, but for the stories that go along with the photographs we keep for ourselves. Photographs conceal as much as they reveal, misdirect as often as they clarify. Many times, they are the only records we have of long-lost relations or forgotten places. The photographs by and about Filipinos in Hawai'i that we have assembled in this book span the last 60 years of the Filipino Centennial in the state, which commemorated the first significant arrival of colonial subjects into what was then known as "the Territory"—from one outpost of the United States's empire to another. The years after World War II offer a bright dividing line between the plantation era that dominated the islands and the tourism period that replaced it.

Filipinos are an indelible part of Hawai'i's three main economic engines: tourism, the US military, and agriculture. On any given day, more than 170,000 tourists (more politely referred to as "visitors") arrive, as well as another 100,000 by cruise ships. Of the six billion arriving every year, 73 percent are from the continental United States. Combined with their international counterparts, tourist spending in one year amounts to $10 billion. That doesn't come close to how much the federal government spends—nearly $25 billion a year—on what is geographically the largest of the US unified service commands, with authority over assets that cover more than 50 percent of the earth's surface from California to the Maldives and from the Arctic to the Antarctic. Anchored in Honolulu, this command encompasses a world that tourists are largely unaware of during their vacations: more than 350,000 personnel attached to various services, five aircraft carrier strike groups, 180 ships, 1,900 aircraft, five Stryker brigades, and two Marine Expeditionary Forces. Most on holiday would not know as they stumble back to their Waikiki hotel suites that one out of four persons in Hawai'i is connected to the military. While no longer playing the same role it did prior to World War II, agriculture continues to be a major player in the island chain's economy with a $44-million revenue in sugar crop. The total $600 million in crop and livestock sales involves sugar production and the sale of pineapples, flowers, and nursery products such as seeds, macadamia nuts, and coffee.

Paradise lost was the title of the first theme
But now in a dream, you know I'm dreamin' a new dream

— Sudden Rush, "Paradise Found" in the album *Ku'e* (1997)

Hawai'i's reputation as a paradise is partly maintained by a multicultural, melting pot myth. In a locale where no single racial group is numerically dominant, 17 percent of the population was born outside of the United States, 57 percent was naturalized as US citizens, 24 percent of the so-called "foreign born" entered the state after 2000, 86.5 percent of the same group trace its ancestry to Asia or Oceania, and 21 percent speak an Asian or Pacific Islander language at home. One version of Filipino histories in Hawai'i contrasts the trials of the plantation era because of greater socioeconomic mobility found in the post–World War II era, more easily digested as a tale of rags-to-riches, the march towards the American Dream. The measures of success for the arc of this kind of story almost always turns to select individuals who became exemplary Filipinos—a governor, a beauty pageant queen, or athletes and entertainers. If history were only about individuated achievements, then there would be quite a lot to celebrate, probably to no end with all the coronation balls and award dinners scheduled in any given year. But Filipino histories in Hawai'i are more than tallying up brown faces in so-called high places. For the majority, paradise might as well be like how it is sung in the song, "Anywhere But Here."

The sobering realities of Filipinos' stunted occupational statuses, stagnant income levels, and frustrated educational achievements disturb any carefully crafted fantasy of immigrant success and upward mobility. The fiction of the Aloha State masks the following facts: despite the material gains that individuals have made and used as measures of success against everyone else, Filipinos, as one of the largest populations on the islands, along with Native Hawaiians and Samoans, were vastly underrepresented in management and professional ranks while overrepresented in blue-collar sectors of production, transportation, and service industries as food processors, truck drivers, seamstresses, laborers, retail clerks, and hotel staff.

Life been defined by nights under skies
Next to the line, where the sea meet land
Got both feet planted in the sand
. . .
I came directly from the place
Seen a whole lotta homes erased
Faced with an ice epidemic so large it'll put global warming on pause
Warning all frauds
No, it's not a walk on the beach
. . .
News flash jerk! Hawai'i ain't free
And I vowed on the day I became an MC
Never not say what I'm made to speak from
The same rock Barack walked and breathed
And be the smoke signals from them wowie trees
And more information is what we need

— Blue Scholars, "HI-808" in the extended play (EP) recording *Oof!* (2009)

When changes did occur, the evidence was not to be found in any one person's attainment of an office or a starring role. Dignity, resources, and life chances and choices have bettered and widened when Filipinos in Hawai'i challenged authorities, disputed unjust conditions, laid claim to long histories of resistance from the Philippines that have echoed throughout the diaspora, and offered themselves as allies to movements for sovereignty. The partial views we offer in this book are a lot like the kinds of histories that Howard Zinn talked about when he cross-examined US ideologies. Photographs, like histories, are partial views in that they are "only a tiny part of what really happened," and that all photographers, like historians, inevitably take sides, deciding what to include, omit, emphasize, or de-emphasize. We hold out for the promise that Filipino stories in Hawai'i should be told by any means necessary, not only through photography but through music, choreography, poetry, and public policies—on whatever stage can take the weight. Partial views may be all that we have; we need your help in describing what was left out of the frame.

This book's organization was inspired by our classroom experiences. While we have not co-taught courses together, we have, over our combined 31 years of teaching, assigned our students versions of the following tasks: either to narrate their history through family photographs or to choose a theme that can be illustrated through various found images such as advertisements or political cartoons. In *Filipinos in Hawai'i*, we have paired a handful of those topics with photographic selections that we hope will link biography with history and personal stories with larger, sometimes impersonal, frames of reference. We have also chosen to take on our own assignments by working with two individuals to help narrate their families' journeys to and through Hawai'i. Throughout the book, Ilokano terms are sometimes used rather than Tagalog terms, reflecting the usage by the photograph contributor or interviewee. The accompanying website (www.FilipinosInHawaii.info) has additional galleries of photographs not included in this book along with a historical timeline of Filipino history in the Philippines and Hawai'i.

One

RITUALS

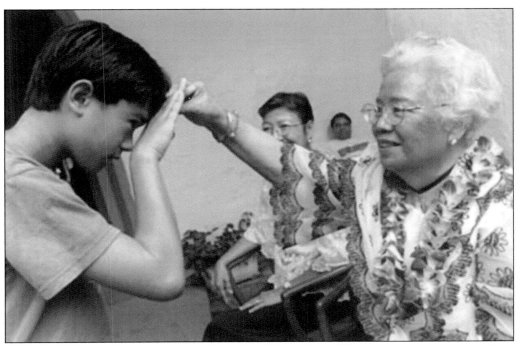

A boy performs *mano po*, which literally means "hand please." It is a sign of respect to elders. (Courtesy of the *Fil-Am Courier.*)

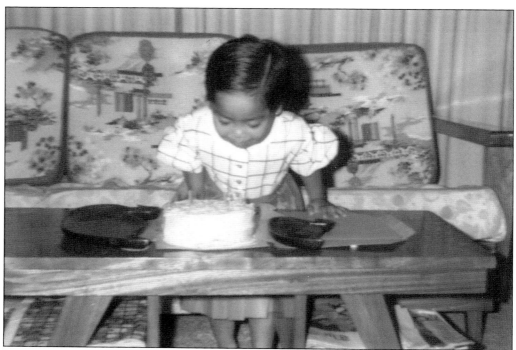

Birthdays are important family and community events. Pictured below, a youngster hoists his cup for a toast. (Both, courtesy of Tasha Valenzuela.)

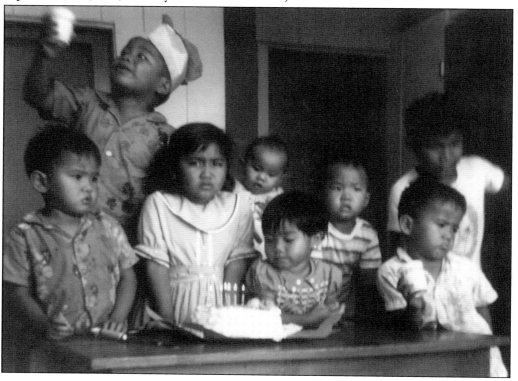

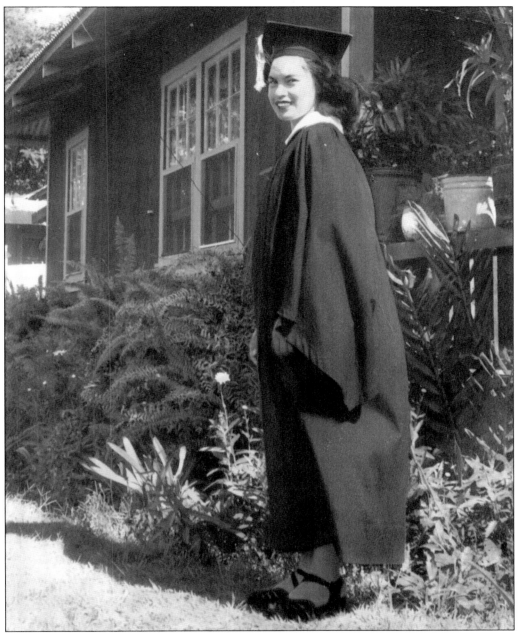

A hopeful graduate gets ready for the ceremony. (Courtesy of Ernest Libarios.)

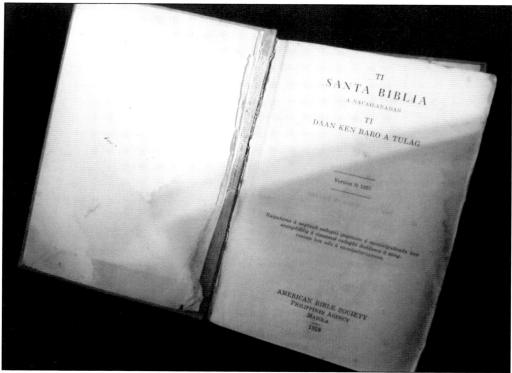

A grandson recalls how his *lolo* (grandfather) had his Christian Bible buried with him. (Courtesy of Bill McElligott.)

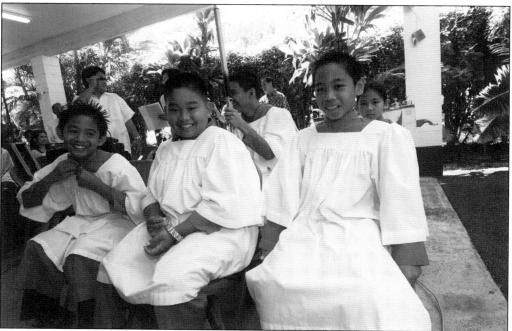

Three altar servers fidget during mass. (Courtesy of Tim Llena.)

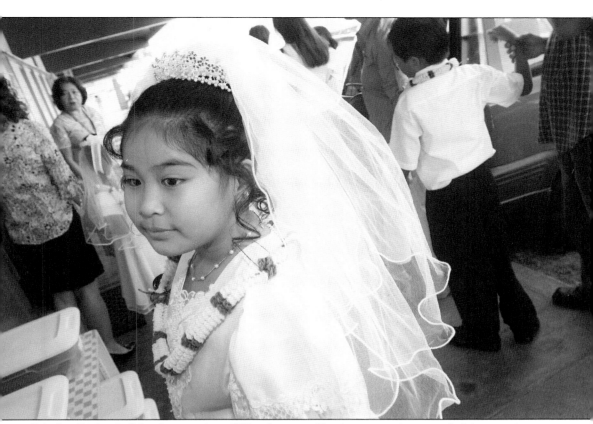

Scholar Richard Schechner writes, "Rituals are collective memories encoded into actions. Rituals also help people . . . deal with difficult transitions, ambivalent relationships, hierarchies, and desires that trouble, exceed, or violate the norms of daily life, [where] people can become selves other than their daily selves . . . Initiations, weddings, and funerals are rites of passage— from one life role or status to another." (Courtesy of Tim Llena.)

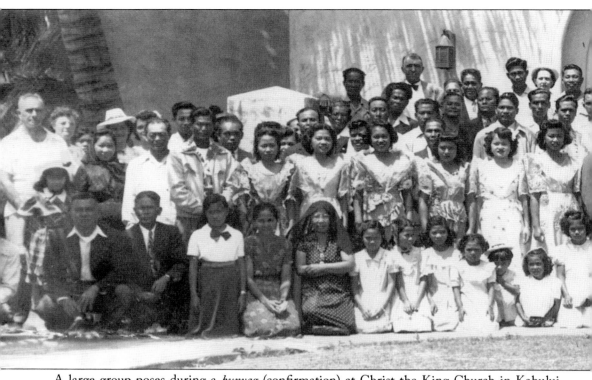

A large group poses during a *bunyag* (confirmation) at Christ the King Church in Kahului,

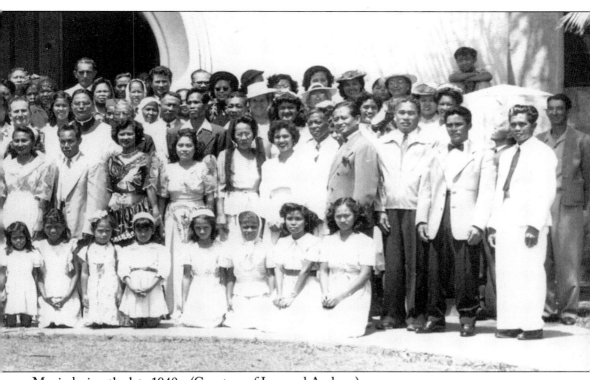

Maui, during the late 1940s. (Courtesy of Leonard Andaya.)

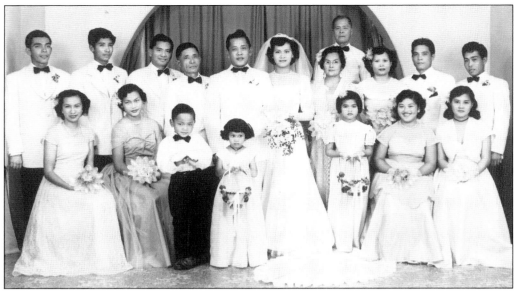

The bride pictured in this early-1950s photograph is Profiria Tabuso, and the groom is Nicholas Nacion. Domingo Los Baños's sister is seated on the right. (Courtesy of Domingo Los Baños.)

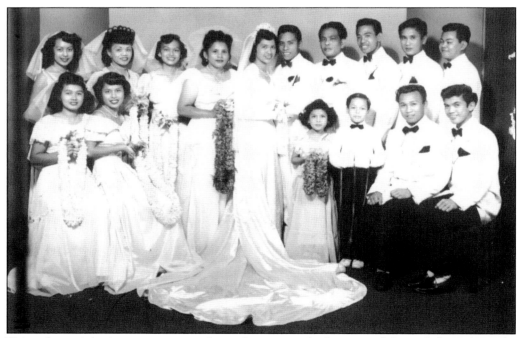

Using the social science concepts such as adaptation, which were widely used throughout the 1960s and 1970s, scholar Ruben Alcantara wrote that Filipinos in Hawai'i relied on "fictive kinship, multiple sponsorship at wedding and baptisms, voluntary organizations, and familial schema in communal households" in order to "extend bonds of neighborliness." (Courtesy of Ernest Libarios.)

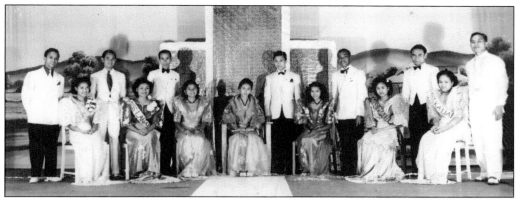

Miss Big Island Ramona Duterte (seated third from the left) is photographed at the Miss Filipina Pageant during the early 1940s. (Courtesy of Ernest Libarios.)

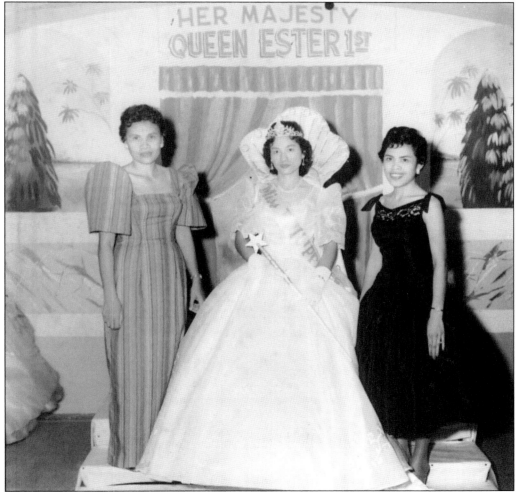

Doris Andaya (left) poses with queen Ester (center) and Sophie Andaya on Naska, Maui, in this c. 1955 photograph. (Courtesy of Leonard Andaya.)

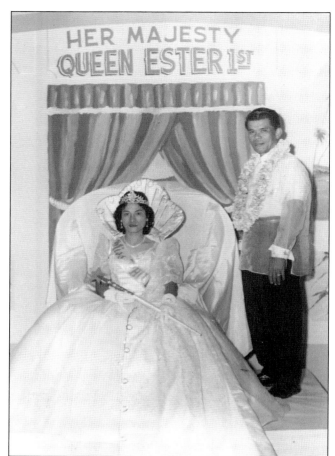

Queen Ester (sitting) and Alejo Andaya pose for the coronation marking the Rizal Day celebrations held at the Filipino clubhouse on Naska, Maui, in this c. 1955 photograph. (Courtesy of Leonard Andaya.)

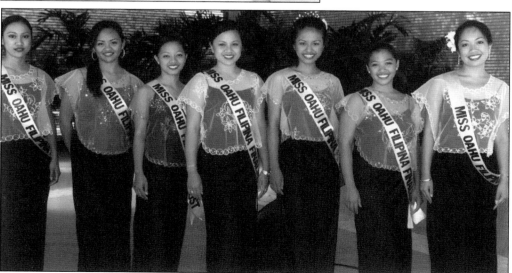

Finalists for the Miss Oahu Filipina pageant pose together. (Courtesy of the Filipino Community Center.)

Teen pageant contestants pose for a photograph in Honolulu. (Courtesy of the Filipino Community Center.)

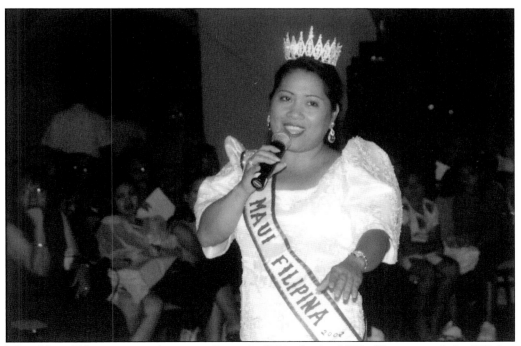

Miss Maui Filipina serenades an audience in Waipahu in 2002. (Courtesy of the Filipino Community Center.)

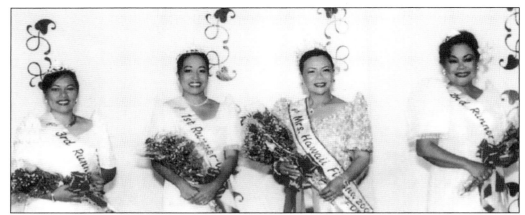

Mrs. Hawai'i Filipina, third from the left, is pictured with runner-ups. (Courtesy of the Filipino Community Center.)

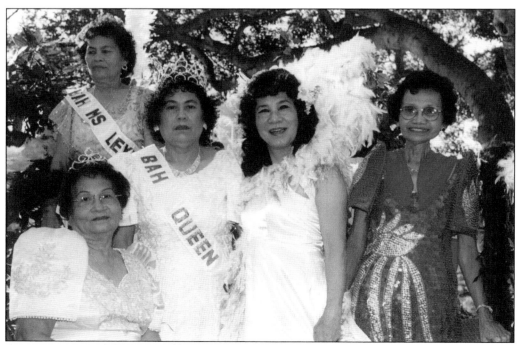

A queen poses with her court. (Courtesy of the Filipino Community Center.)

The young man's hat signified that he was part of a membership in a mutual aid or benevolence society. (Courtesy of Ernest Libarios.)

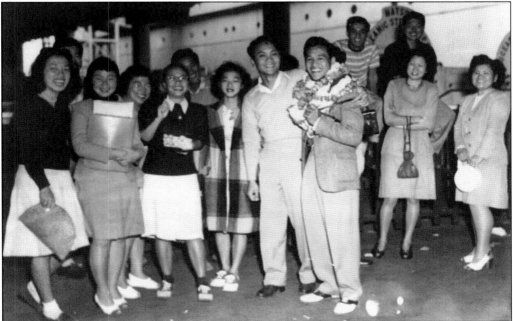

Friends gather for a young student's *despedida* (farewell celebration) as he makes his way to the East Coast for college. (Courtesy of Domingo Los Baños.)

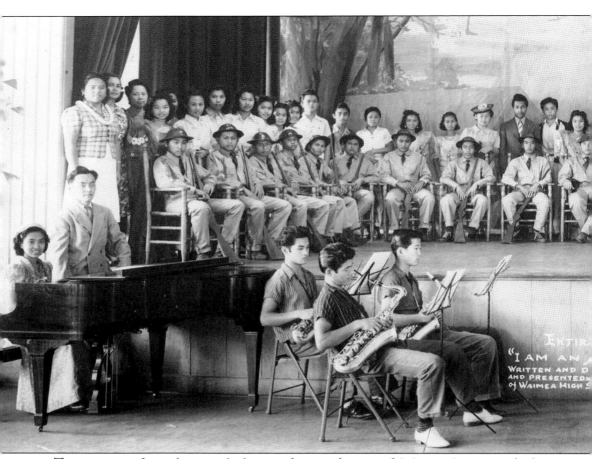

The cast poses for a photograph the a student production of *I Am an American*, which was written and directed by S. Reataso and presented by the Filipino students of Waimea High

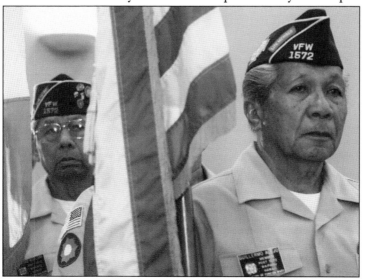

Members of the Veterans of Foreign Wars Post 1572, 1st Filipino Infantry Regiment, which was based in Waipahu, participate in the *Araw ng Kagitingan* (Day of Valor), a day to commemorate the fall of Bataan on April 9, 1942. (Courtesy of Tim Llena.)

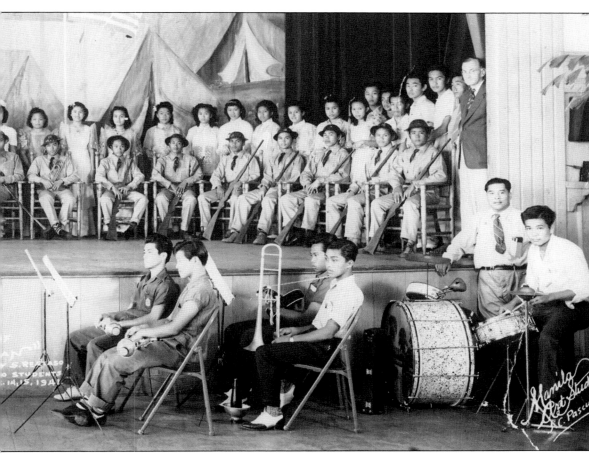

School on March 14–15, 1941. (Courtesy of Domingo Los Baños.)

Former soldiers commemorate Independence
Day. (Courtesy of Tim Llena.)

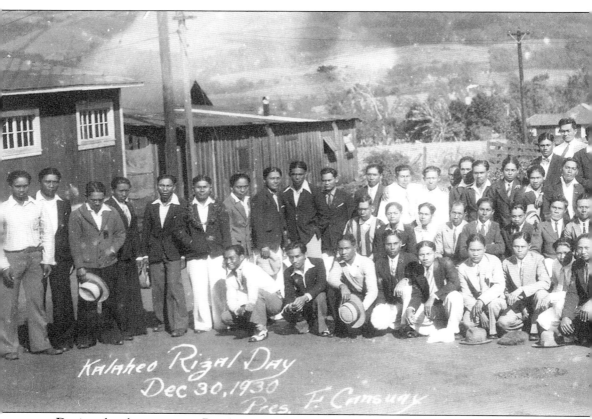

During the plantation era, Rizal Day served as an important religious and cultural celebration for the Filipino community, commemorating the martyrdom of Dr. José Rizal, one of the national heroes of the Philippines. Festivities usually included a reenactment of Rizal's final

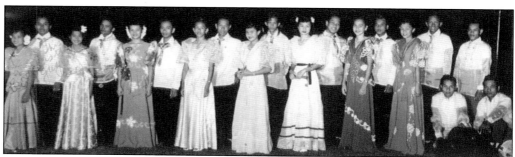

The Wainee Village Filipino Folk Dancers pose for a photograph on Maui on December 30, 1950. (Photograph courtesy of the Alexander and Baldwin Sugar Museum.)

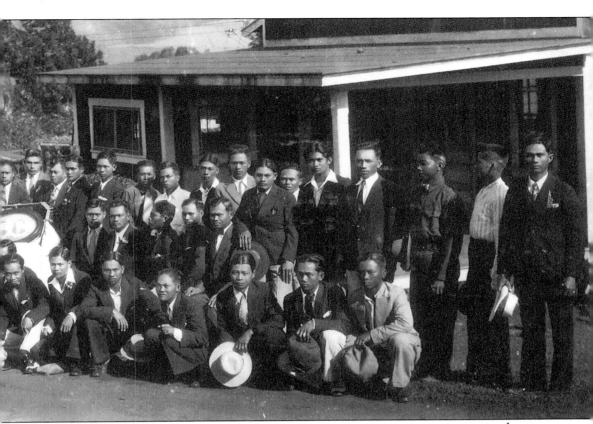

day before he was executed by the Spanish and recitations of his famous poem *Mi Último Adiós*. This photograph was taken on Kalāheo, Kaua'i, on December 30, 1930. (Courtesy of Domingo Los Baños.)

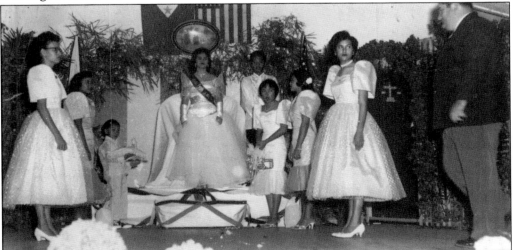

The photographer captured a candid show of a rehearsal with the Rizal Day court at the Orpheum Camp on Pā'ia, Maui, in this c. 1959 photograph. (Photograph courtesy of the Alexander and Baldwin Sugar Museum.)

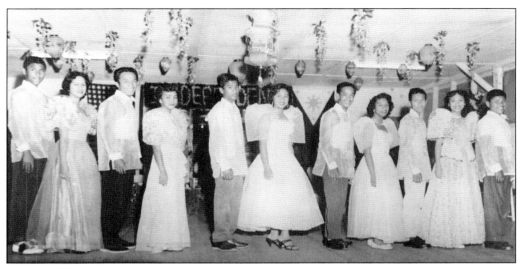

In this c. 1956 photograph, Maurice Andaya (far left), Patrick Borge (fifth person from left), Elsie Nefulda (sixth person from left), and Leonard Andaya (far right) pose with their friends at the Rizal Day celebration dance at the Naska clubhouse on Maui. (Courtesy of Leonard Andaya.)

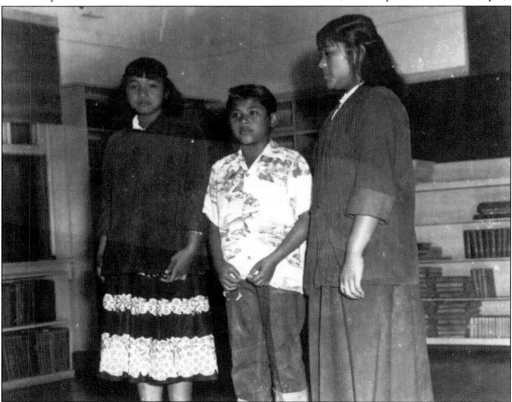

In this c. 1951 photograph, pictured from left to right are Corazon Toribio, Leonard Andaya, and Barbara Borge performing at a Spreckelsville School function on Maui. (Courtesy of Leonard Andaya.)

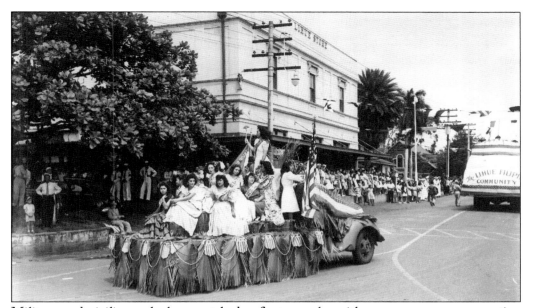

Military and civilian onlookers watched a float pass by with young women representing Australia, New Zealand, the Philippines, Great Britain, Hawai'i, France, and Mexico, among others. They are directly behind another float sponsored by the Lihue Filipino Community on Kaua'i. (Courtesy of the Kauai Historical Society.)

Pictured here are revelers on the parade route for the Filipino Fiesta. They were heading toward Kapi'olani Park for the festivities on O'ahu. (Courtesy of the *Fil-Am Courier*.)

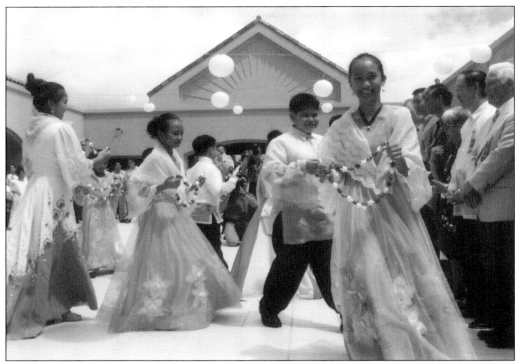

Taking more than 10 years to plan, design, build, and raise funds, the Filipino Community Center held its grand opening ceremony in June 2002. In this photograph, children in their formal attire are honoring dignitaries and special guests. (Courtesy of the Filipino Community Center.)

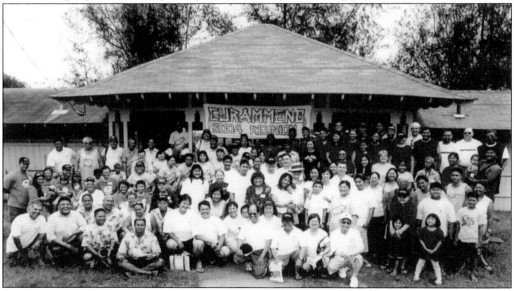

At Niumalu Park, 120 members of the Curammeng family gather for a family reunion in 2004. Marcos Curammeng came to Kaua'i from the Philippines in 1922 on a three-year labor agreement for the Hawaiian Sugar Planters Association. With many Curammeng family members on Kaua'i, others are found in Alaska, Colorado, and California. (Courtesy of the *Fil–Am Courier.*)

Alejo Andaya (in the foreground, turned away from the camera) is here at a picnic with friends at Spreckelsville Beach on Maui sometime in the 1950s. (Courtesy of Leonard Andaya.)

On the burner is *kalding* (goat) in Kalihi, Oʻahu. Describing Filipino cooking, poet Al Robles writes, "Use plenty of garlic and pour lots of vinegar in a barrel." (Courtesy of Jerel P. Salviejo.)

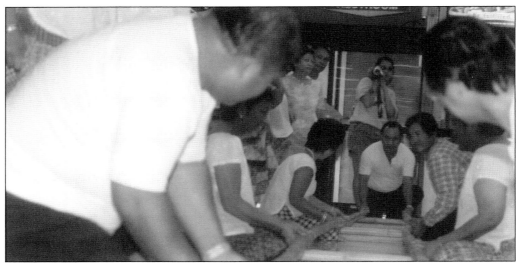

The *tinikling* dance was introduced to the United States on the Ed Sullivan Show, which garnered a 40 million–member audience, during the late 1950s. The tinikling has now become a staple of community gatherings. Describing the cultural dance in "The Day the Dancers Came," Bienvenido Santos writes, "A boy and a girl sat on the floor holding two bamboo poles by their ends flat on the floor, clapping them together, then apart, and pounding them on the boards, while dancers swayed and balanced their lithe forms, dipping their bare brown legs in and out of the clapping bamboos, the pace gradually increasing into a fury of wood on wood in a counterpoint of panic among the dancers and in a harmonious flurry of toes and ankles escaping certain pain." (Courtesy of the Filipino Community Center.)

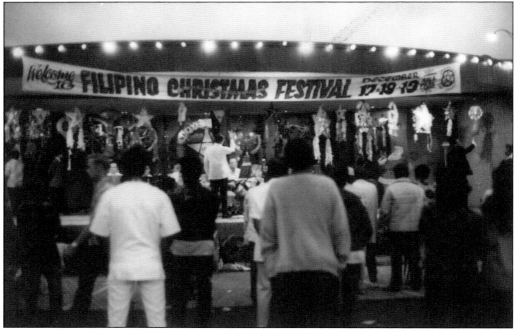

Well into the night, friends and neighbors gather for a Christmas Eve celebration, *Pasko sa Nayon*, on Oʻahu in 1971. (Courtesy of the Hawaiʻi State Archives.)

Family members have marked this final resting place with flowers and candles at Ewa Plantation Village, Oʻahu. (Courtesy of the Hawaiian Collection, University of Hawaiʻi at Mānoa Library.)

Even with an abundance of children, the passing of an infant is no less difficult to bear. Young Francis D. Cornellio was born in 1939. (Courtesy of Ernest Libarios.)

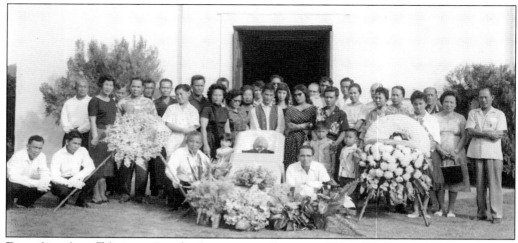

Describing how Filipinos view death as a rites of passage, Karen Pagampao writes, "Death is not the end but rather a continuation of kinship ties between the survivors and the deceased. Death is a crisis in life that has to be expected." (Courtesy of the Kauai Historical Society.)

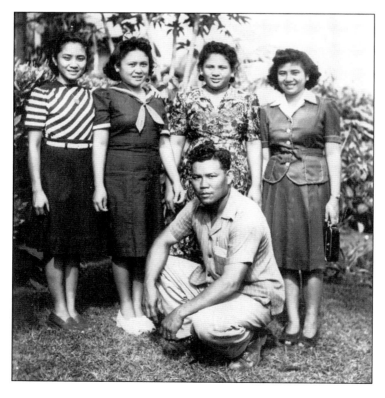

The Duterte sisters pose for this c. 1940 photograph. Pictured from left to right are Mary, Christina, Fanny, and Ramona, and the male in front is unidentified. (Courtesy of Ernest Libarios.)

This c. 1976 photograph of a young boy from Antamok, Benguet, Philippines, was sent to his cousins in Hawai'i. (Courtesy of Tasha Valenzuela).

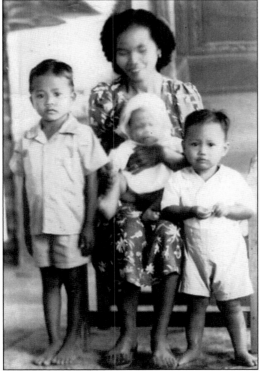

Ellen-Rae Cachola shares her photograph of her grandmother Simeona "Mary" Cachola with her two younger sons, Ernesto Cachola (standing, left) and Rogelio Cachola (in lap), and her nephew Miguel Collo. The image was taken in a studio in Narvacan, Ilocos Sur, in 1947. (Courtesy of Ellen-Rae Cachola.)

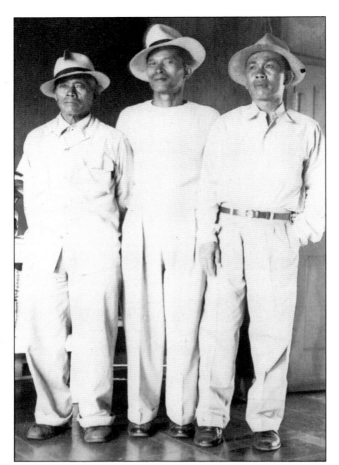

Pictured from left to right, this 1940s photograph features province-mates from the Philippines: Madalino Celeres, Cataline Aboloc, and Pedro Libarios. (Courtesy of Ernest Libarios.)

The Libarios family gathers for the funeral of young Jamie, who was six months old when he passed away from pneumonia. He was the second child of Hermanhildo Libarios (left of center post) and Fanny Libarios (right of center post). (Courtesy of Ernest Libarios.)

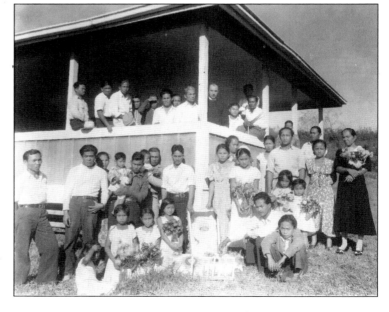

Family members exchanged postcard photographs like this one, which pictured (from left to right) Roselfida Siobal, Vironica C. Amano, and Verginia De La Cruz. (Courtesy of Tasha Valenzuela.)

This early-1950s studio portrait features Lucy Libarios Nagtalon (left) with her mother, Concing Libarios Burns. (Courtesy of Ernest Libarios.)

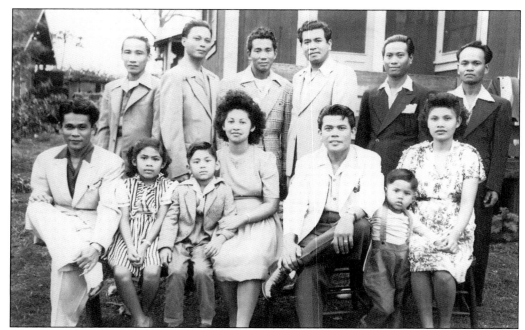

A group poses for this c. 1945 photograph at Camp Two in Spreckelsville, Maui. Pictured from left to right are (first row) Mateo Pascua, Sophie Andaya, Maurice Andaya, Mercedes Pascua, Alejo Andaya, Leonard Andaya, and Doris Andaya; (second row) all are unidentified except for "Uncle Haole" at the far left and "Tata Lino" at the far right. (Courtesy of Leonard Andaya.)

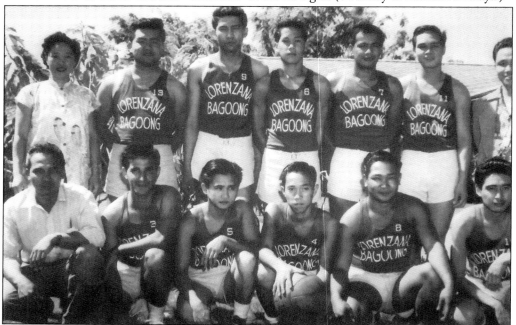

Pete Behasa recalls how the social club he participated in as a kid created several sports opportunities, including the creation of a sponsored basketball team known as the Lorenzana Bagoong in 1954. (Courtesy of eFil: Filipino Digital Archives and History Center of Hawai'i.)

Pegelio and Mary Arzaga (seated) celebrated their 43rd wedding anniversary in 1979. Standing behind them are sisters Betty, Norma, Nellie, Constance, and Judy. In a 2009 interview with sisters Norma and Constance, Dr. Patricia Brown wrote, "They are proud Filipinas—refreshingly unpretentious, very approachable, independent thinking, and quick to share their humorous outlook on life." (Courtesy of eFil: Filipino Digital Archives and History Center of Hawai'i.)

Rosario Busmente celebrates her birthday with most of her grandchildren. (Courtesy of the *Fil-Am Courier.*)

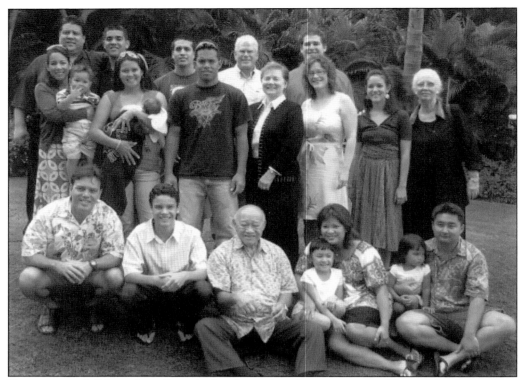

Domingo and Mary Los Baños's family gather for a reunion. (Courtesy of Domingo Los Baños.)

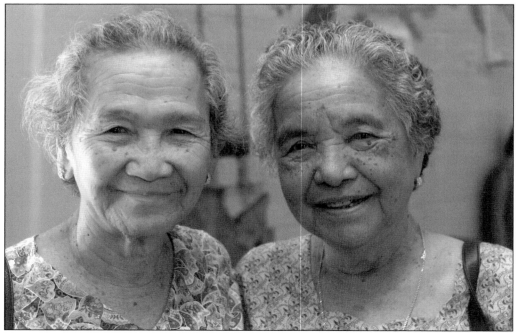

Two friends share their beautiful smiles. (Courtesy of Tim Llena.)

The year 2006 marked the centennial of Filipinos arriving in Hawai'i. For the Filipino Centennial, Tim Llena photographed several families. Both of these photographs feature three generations of family members. (Both, courtesy of Tim Llena.)

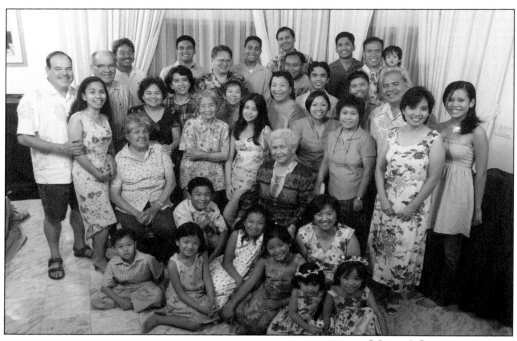

Manuel Quezon observed the following about family gatherings held in the United States, and he said these were occasions "where love and affection are the predominating spirit." (Courtesy of Tim Llena.)

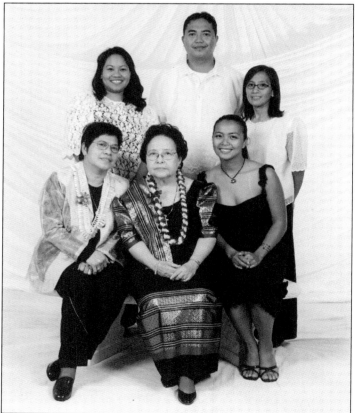

Professor Teresita Ramos (seated, center) is photographed with the Filipino language faculty from the University of Hawai'i at Mānoa. (Courtesy of Teresita Ramos.)

Pete Behasa was born in Kealakekua (South Kona), Hawai'i, in 1926. He grew up on a coffee plantation and later moved to O'ahu where his father worked for the Oahu Sugar Company and served in the US Army. He is pictured in this 2007 photograph at the Hawai'i Plantation Village, where he has been a docent. (Courtesy of eFil: Filipino Digital Archives and History Center of Hawai'i.)

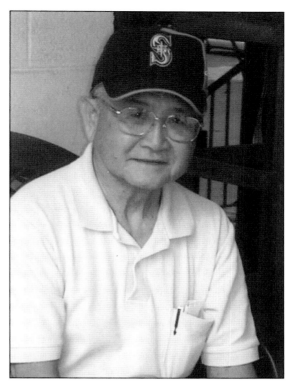

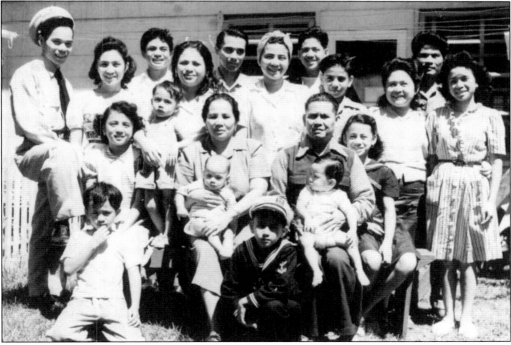

The Duterte family poses for a photograph at Honolulu's Hickam Air Force Base in 1947. (Courtesy of Ernest Libarios.)

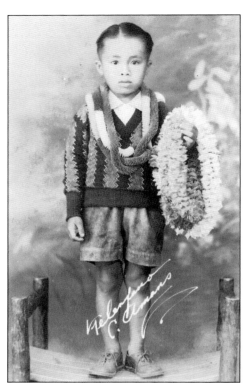

Born on January 5, 1927, a young Telesforo
C. Amano poses with several lei. (Courtesy of
Ernest Libarios.)

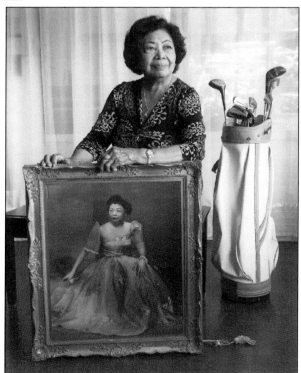

Tim Llena photographed a woman
holding a portrait of her younger
herself. (Courtesy of Tim Llena.)

Three

LABOR

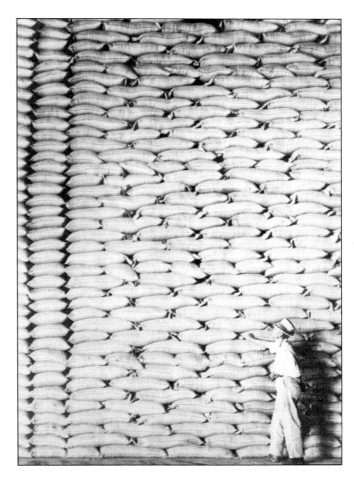

Basilio Agsalud contemplates
a wall of commodities.
(Courtesy of the University of
Hawai'i Press.)

This 1950s photograph shows a diverse mix of workers that were of Chinese, Korean, Puerto Rican, Japanese, Hawaiian, and Filipino heritage. This image was taken at the Kapaa Cannery (for pineapple processing) in Kapaa, Hawai'i, which is currently the site of the Pono Kai Resort. (Photograph by Robert Brooks Taylor; courtesy of the Kauai Historical Society.)

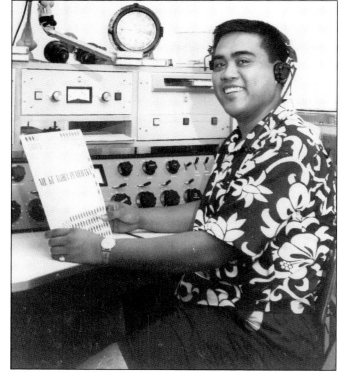

In this photograph, Jaime B. "Braddah Kimo" Nelmida, a former radio announcer at KTOH and KUAI 720 and musician at the Kauai Surf Hotel and Kauai Resorts, holds an album titled *Me Ke Aloha Pumehana*. (Courtesy of the Kauai Historical Society.)

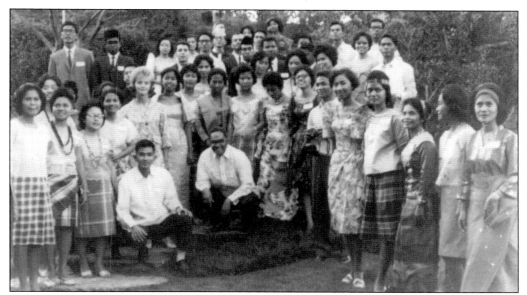

Language instruction pioneer Teresita Ramos (third from the left) is pictured with scholars from the East-West Center (EWC) in Honolulu in 1966. Since it opened in 1960, more than 50,000 scholars have participated in EWC programs. (Courtesy of Teresita Ramos.)

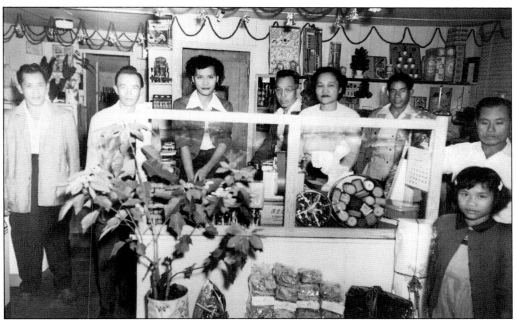

While many Filipinos served as field labor for the sugar and pineapple plantations since their importation in 1906, there were pioneering businesspeople like Lucia Simon Los Baños (seated fifth from the left). To Lucia's right is Domingo Los Baños Sr. Nicholas Nacion (second from the left) and Profiria Tabuso met and worked at the store. This is a photograph of Lucia in the last store she owned and operated, Lucia's Tienda, in Laway, Kaua'i, in 1949. (Courtesy of Domingo Los Baños.)

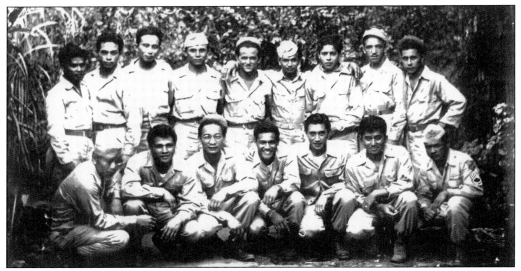

Pictured here are members of the 1st Filipino Infantry Regiment during V-J Day in Calbayog, Samar, in 1946. Domingo Los Baños, pictured fourth from the left in the first row, volunteered for military service at the age of 18. (Courtesy of Domingo Los Baños.)

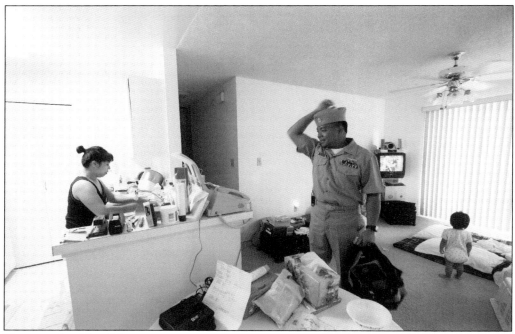

Photographer Tim Llena captures an intimate moment with a family preparing for a seaman's deployment. (Courtesy of Tim Llena.)

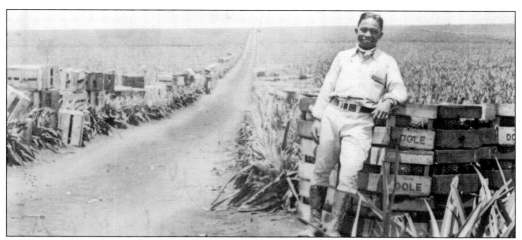

This worker's smile betrays what historians like Gary Okihiro know. Okihiro wrote in his book *Pineapple Culture* (2008) that such workers "resisted exploitation and physical and mental abuse, despite the impositions of a harsh and seemingly all-pervasive system of surveillance and punishment." (Courtesy of Ernest Libarios.)

Waipahu-born drummer Danny Barcelona (1929–2007) started his own group in the 1950s, the Hawaiian Dixieland All Stars. Through a friend, Barcelona was introduced to Louis Armstrong, who invited him to join his All Stars. This invitation started Barcelona's 15-year career that involved tours on four continents as well recording credits on more than 130 sessions. Barcelona appears on Armstrong's "Hello, Dolly!" and "What a Wonderful World." (Courtesy of Henri Hoogewoud.)

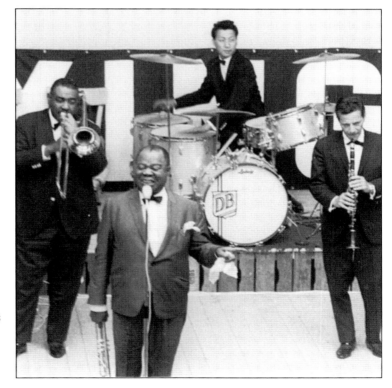

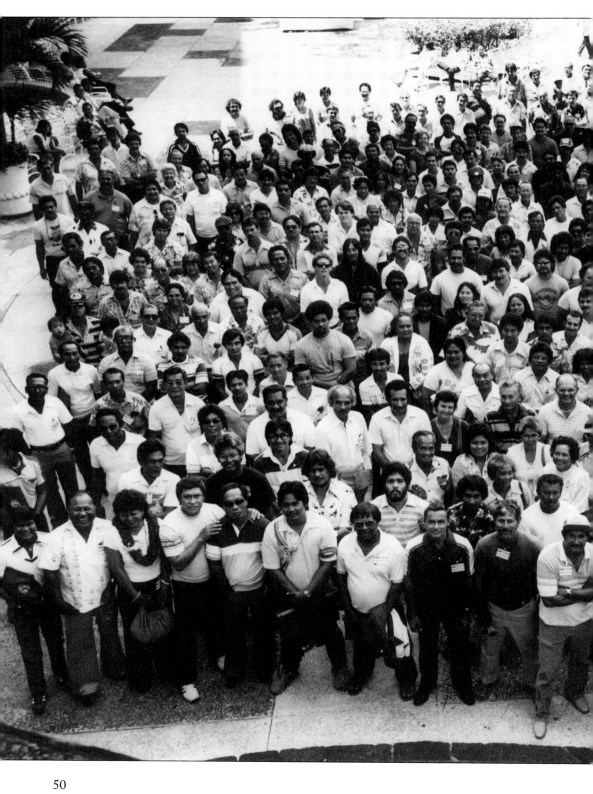

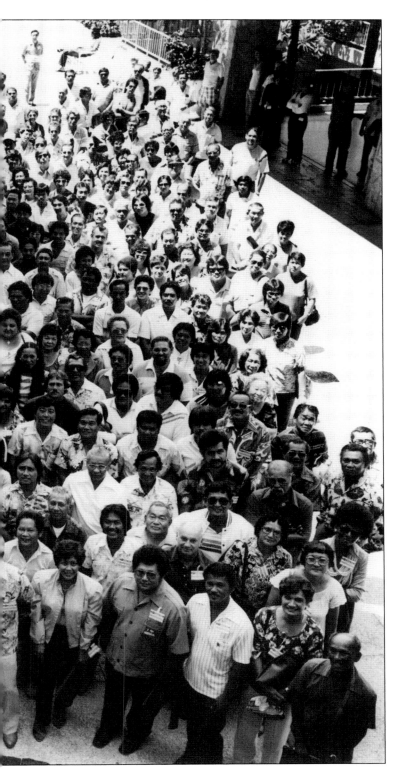

Members of the International Longshore and Warehouse Union (ILWU), Local 142, gather for the 16th Biennial Convention at the Ilikai Hotel in Waikiki from September 19–23, 1983. Former leaders include Lanaʻi ILWU business agent Pedro de la Cruz and longshore worker Carl Damaso, who became president of Local 142 in 1964. (Courtesy of Tasha Valenzuela.)

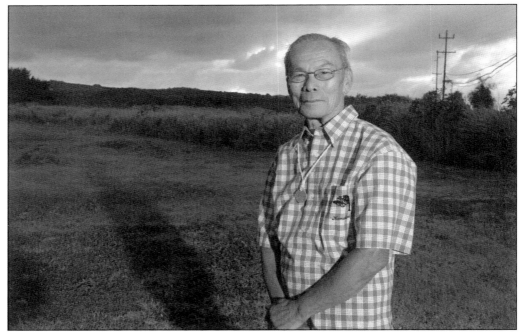

For the Filipino Centennial, Tim Llena photographed a former *sakada* (which scholar Ruben Alcantara defines as a Philippine laborer imported for work on Hawai'i sugar and pineapple plantations) from Kahuku. (Courtesy of Tim Llena.)

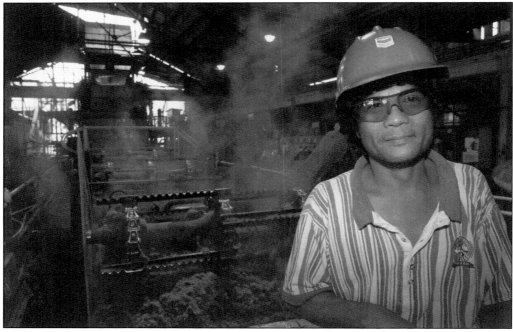

Photographer Tim Llena captures a moment with a contemporary sugar mill worker on Kaua'i. (Courtesy of Tim Llena.)

Four

PLACES

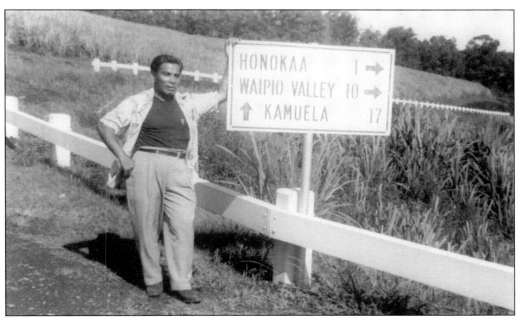

Dimitrio Lalota points the way to Honokaa in this early-1940s photograph. (Courtesy of Ernest Libarios.)

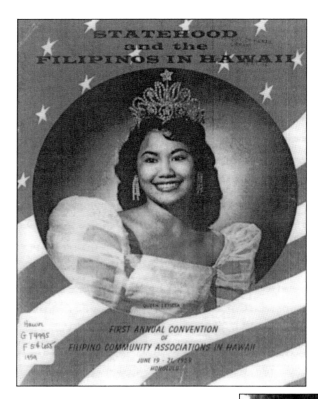

Scholar Kim Compoc analyzes the image of queen Leticia on the cover of the 1959 program celebrating Hawai'i's admission to the union, linking statehood with Filipinos' desire for acceptance. (Courtesy of Hawai'i State Archives.)

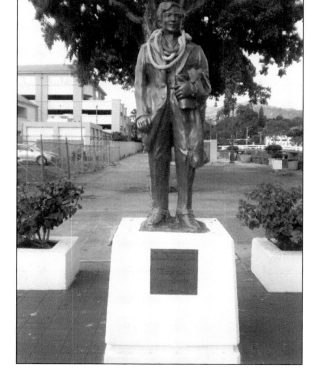

The statue of Jose Rizal was donated by the Filipina Society of Hawai'i in cooperation with Oahu Filipino Community Council and Laoag City Lions Club in 1983. It is located across the river from Chinatown. (Courtesy of Joel Bradshaw.)

A vessel sails leeward in Honolulu harbor. (Courtesy of the Hawai'i State Archives.)

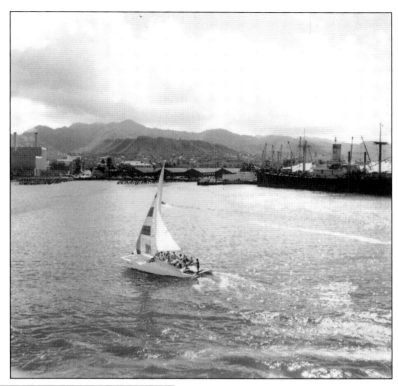

According to the Architect Design Associates, "In 1936, Ewa was a thriving plantation town with eight separate housing villages." This photograph shows houses from Ewa Plantation Village in 1975. (Courtesy of the Hawaiian Collection, University of Hawai'i at Mānoa Library.)

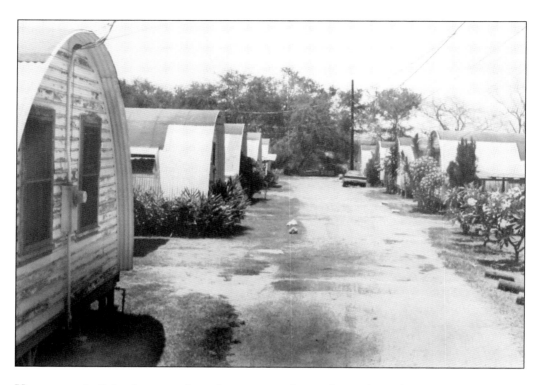

Homes were built by the sugar plantation owners to house the workers who were imported from Japan, China, and the Philippines." This photograph shows signs in Ewa Plantation Village in 1975. (Both, courtesy of the Hawaiian Collection, University of Hawai'i at Mānoa Library.)

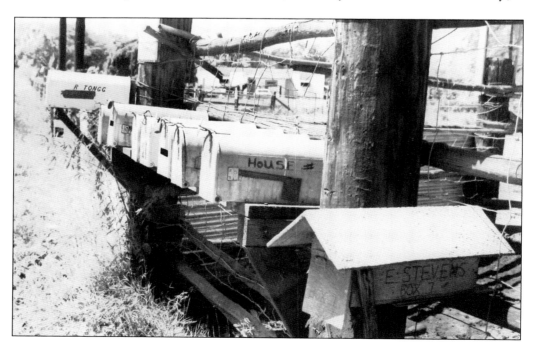

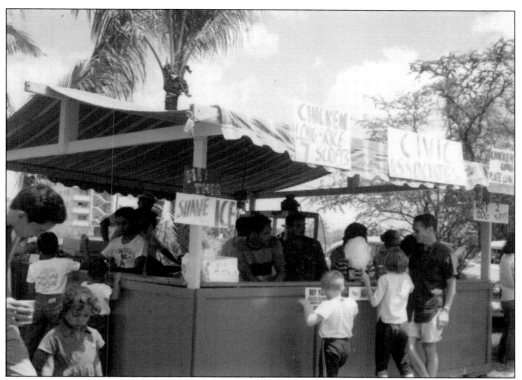

Customers line up for shave ice and chicken long rice at the 1962 Filipino Fiesta that was held at Ala Moana Park. (Courtesy of the Hawaiʻi State Archives.)

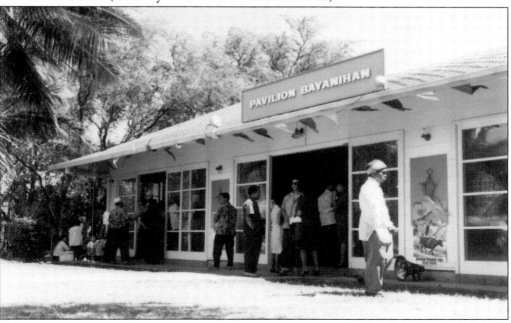

To beat the heat, many festival-goers headed indoors to watch performances at the 1962 Filipino Fiesta that was held at Ala Moana Park. (Courtesy of the Hawaiʻi State Archives.)

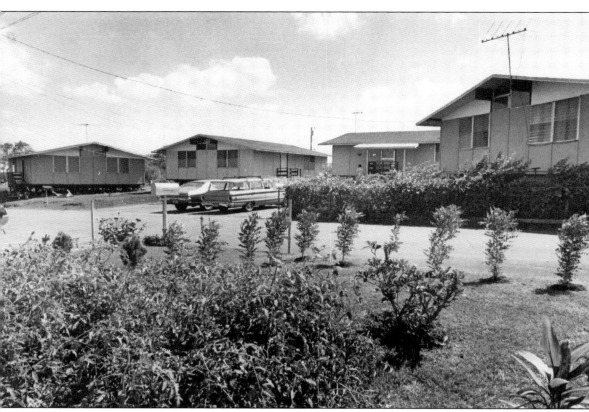

With the leadership of Pete Tagalog, residents of Ota Camp, also known as Makibaka Village, fought to retain local control over their neighborhood. This image features the Makibaka Village gardens in 1975. (Photograph by John Titchen, *Honolulu Star-Bulletin*; courtesy of eFil: Filipino Digital Archives and History Center of Hawaiʻi.)

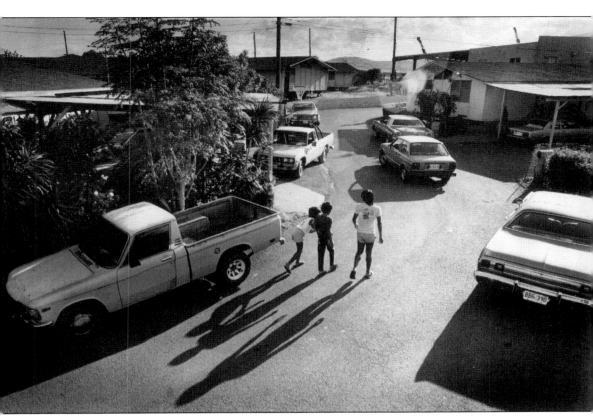

This is an overhead image of Makibaka Village in 1985. (Photograph by Dean Sensui, *Honolulu Star-Bulletin*; courtesy of eFil: Filipino Digital Archives and History Center of Hawai'i.)

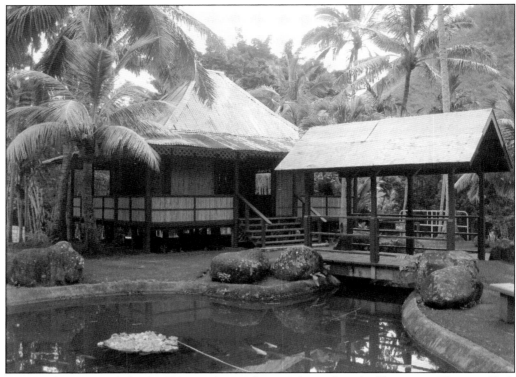

Imagined spaces include this Filipino house that was located in the Kepaniwai Heritage Park in 'Iao Valley, Maui. The park was created by landscape architect Richard Tongg. (Photograph by Joel Bradshaw.)

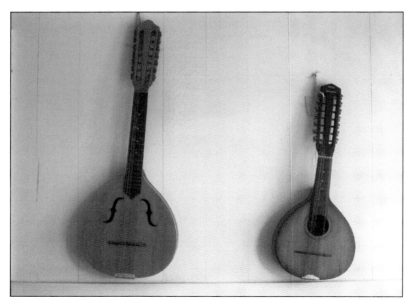

Two *bandurrias* (citterns) adorn the walls of the Filipino house, a replicated home that forms part of the Hawai'i Plantation Village. It was founded in 1992 to give visitors a chance to experience what home-life was like for plantation workers between the late 1800s and early 1940s. (Courtesy of Joel Bradshaw.)

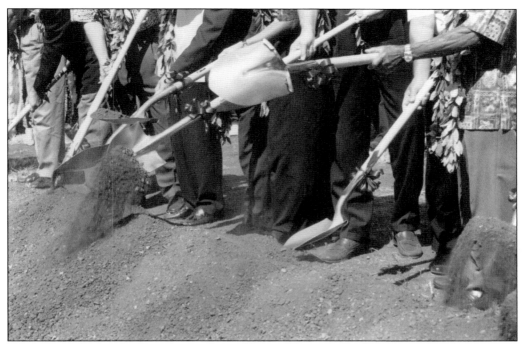

Community leaders break ground on the Filipino Community Center in Waipahu in 2000. (Courtesy of the Filipino Community Center.)

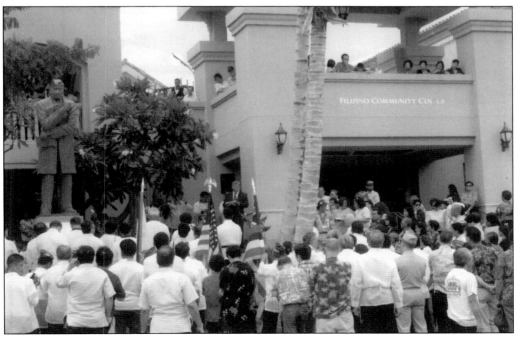

The community gathers for the opening of the Filipino Community Center in 2002. The José Rizal statue stands ready with a quill and notebook. (Courtesy of the Filipino Community Center.)

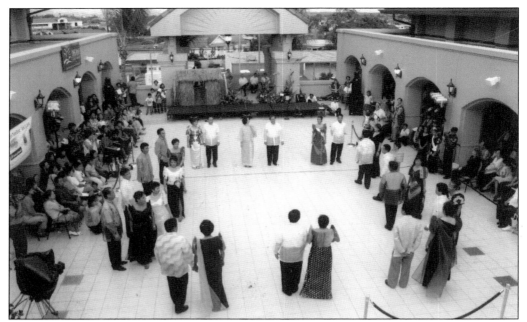

Dancing is about to commence at the Consuelo Courtyard of the Filipino Community Center. (Courtesy of the Filipino Community Center.)

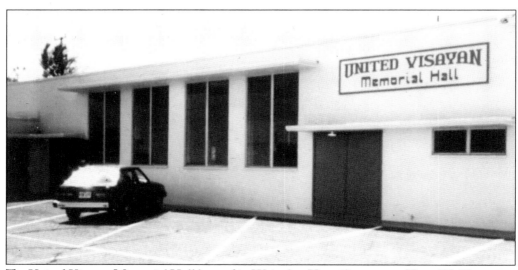

The United Visayan Memorial Hall located in Waipahu, Hawai'i, was near Hawai'i's Plantation Village. It is the clubhouse of the United Visayan community organization. The United Visayan community is made up mostly of Cebuanos from Siquijor, Cebu, Bohol, and Negros Oriental, and it is mainly a mutual aid society. (Courtesy of the *Fil-Am Courier*.)

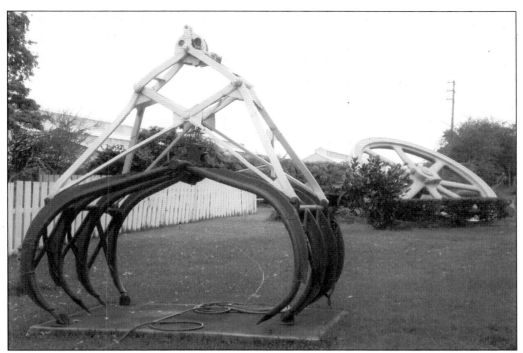

The monopoly held by sugar companies, also known as "Big Sugar," left behind sugar mill tongs and a grinding wheel in the Historic Ewa Plantation Village. (Courtesy of Joel Bradshaw.)

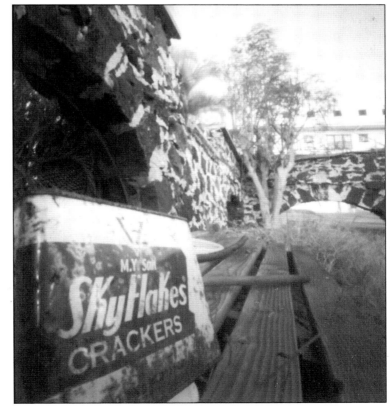

Among the building ruins of Leahi Hospital in Kaimukī, Oʻahu, is a rusted can of crackers. (Courtesy of Ross Togashi.)

Young boys take a ride near the old sugar refinery in Waialua. For most of the 20th century, the Waialua Sugarmill has been one of the major producers for local industry. (Courtesy of Tim Llena.)

Five

COMMUNITIES

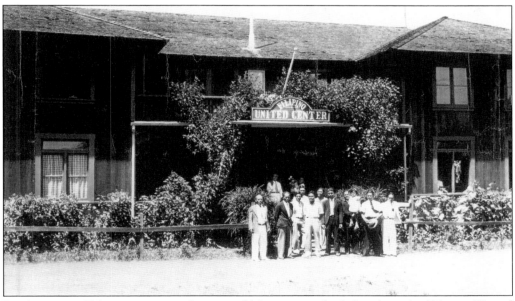

By the 1930s, Filipino meeting places on Oʻahu consisted of churches, the Filipino United Center, Aʻala Park, pool halls, and taxi dance halls. Women's organizations like the YWCA's Filipino Women's Committee began to appear in the 1930s, planning museum visits and luncheons. The Filipino United Center (pictured) was located on Queen Street and had a second-floor dormitory that could accommodate 25 to 50 men. The ground floor featured large rooms for social activities, which were, according to Ruben Alcantara, intended to provide "proper" training for "a people who had no standards of their own." Under the guidance of YMCA superintendent Harry Metcalf, the center's programs included evening classes on language and vocational education.

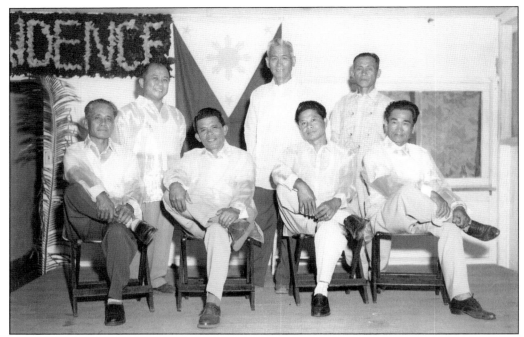

A group of Filipino leaders on Naska, Maui, pose for a photograph during the Philippine Independence Day celebrations in this 1950s photograph. (Courtesy of Leonard Andaya.)

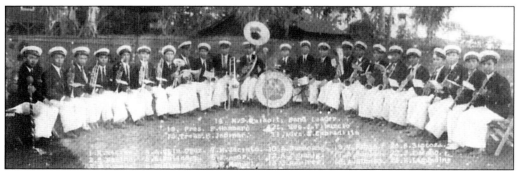

The McBryde Community Band poses for a group shot on Kaua'i in 1930. (Photograph by N. Nakamura, Kalaheo Art Studio; courtesy of Domingo Los Baños.)

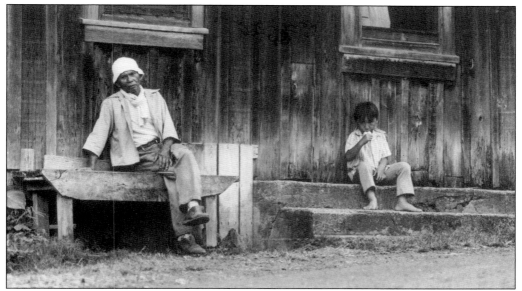

From Kaua'i, this photograph shows Mr. Ocso, a retired cane worker and healer, taking a break. (Courtesy of Ed Greevy.)

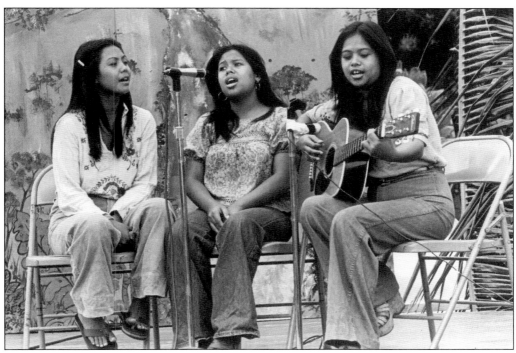

Three singers entertain the crowd at a rally. (Courtesy of Ed Greevy.)

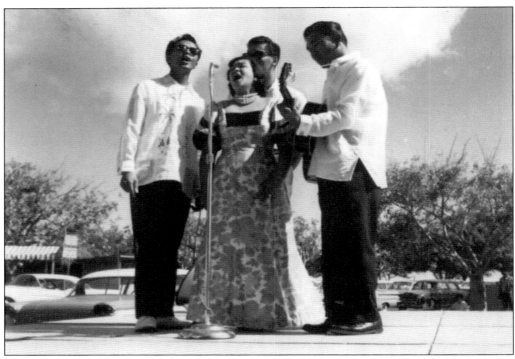

A quartet entertains on the main stage at the 1962 Filipino Fiesta in Ala Moana Park on Oʻahu. (Courtesy of the Hawaiʻi State Archives.)

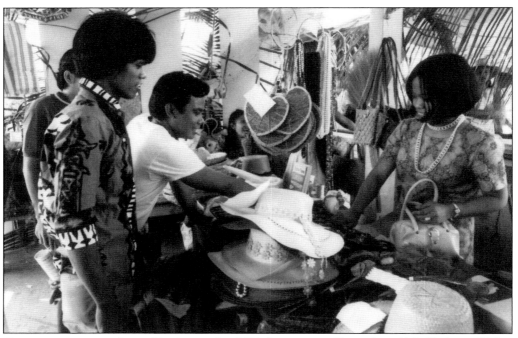

Customers inspect a hat collection at the 1971 Sampaguita Festival in Aʻala Park on Oʻahu. (Courtesy of the Hawaiʻi State Archives.)

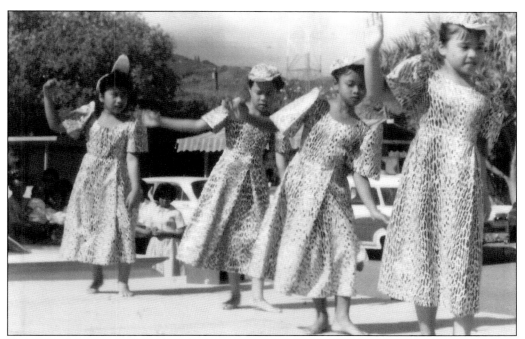

Young performers work hard at the 1962 Filipino Fiesta at Ala Moana Park on Oʻahu. (Both, courtesy of the Hawaiʻi State Archives.)

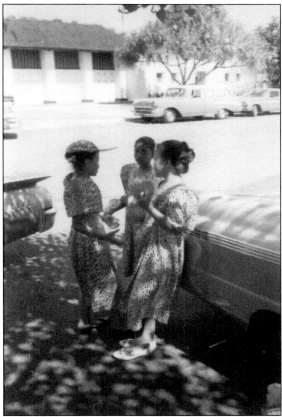

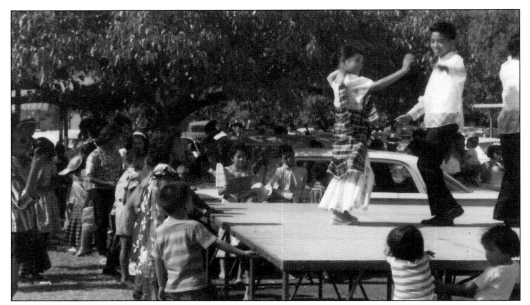

A couple captures the attention of other young ones at the foot of the stage during the Filipino Fiesta at Ala Moana Park on Oʻahu in 1962. (Courtesy of the Hawaiʻi State Archives.)

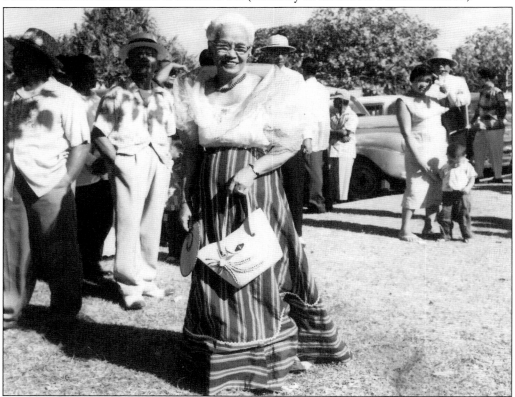

At the same festival, adults dressed elegantly for an outdoor event on Oʻahu. (Courtesy of the Hawaiʻi State Archives.)

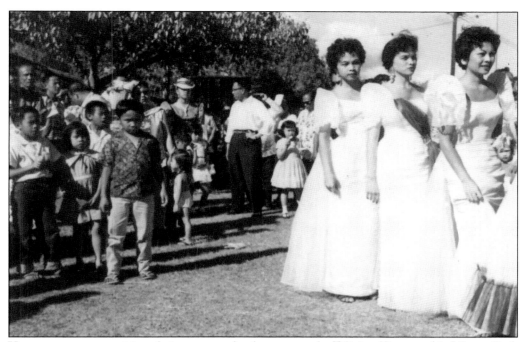

Young women are waiting their turn to take the stage at the Filipino Fiesta at Ala Moana Park on Oʻahu in 1962. (Courtesy of the Hawaiʻi State Archives.)

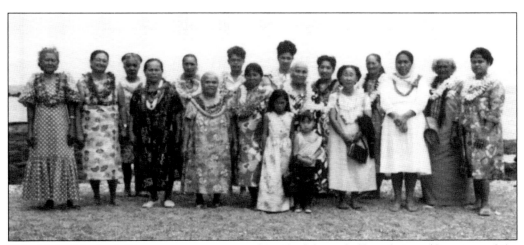

This Aloha Mother's Day event was sponsored by the Moncada Foundation. (Courtesy of the Kona Historical Society.)

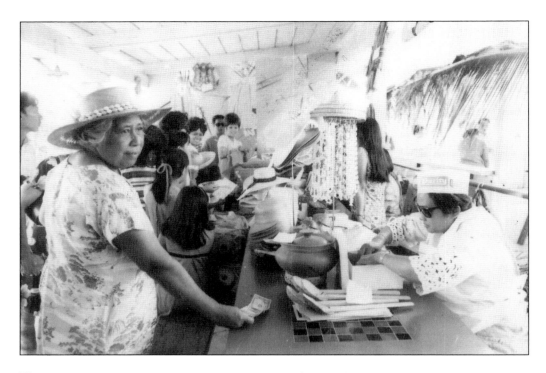

The community comes out to support local vendors and enjoy each other's company at the Sampaguita Festival at A'ala Park on O'ahu in 1971. (Both, courtesy of the Hawai'i State Archives.)

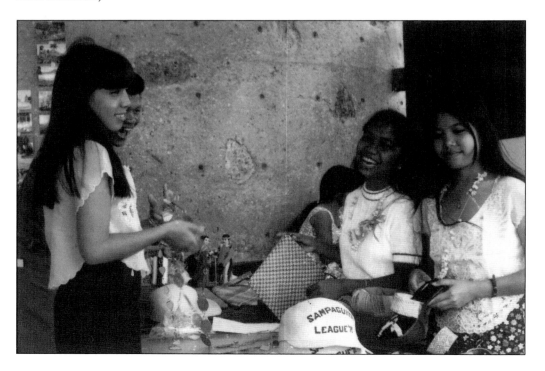

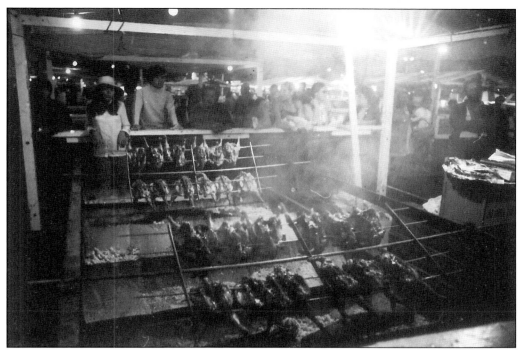

It is not a community event unless there is food and music. These photographs show the Pasko sa Nayon (Christmas Village) festival on Oʻahu in 1971. (Courtesy of the Hawaiʻi State Archives.)

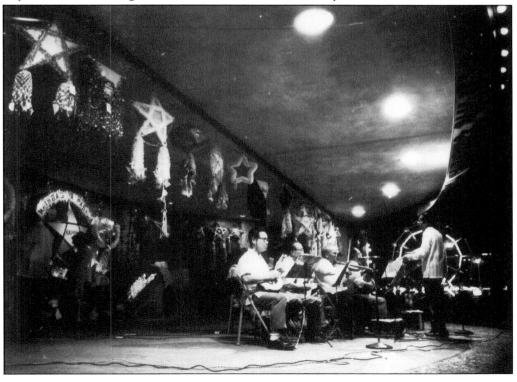

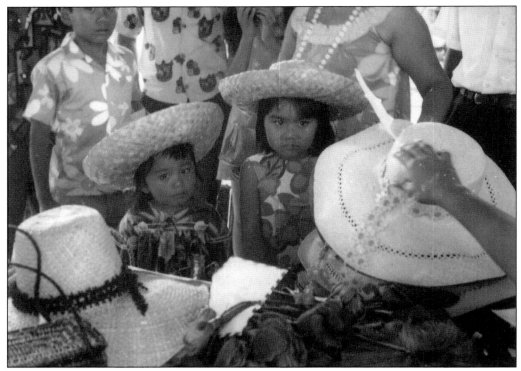

Haggling is an art, and these two girls are ready to bargain at the Sampaguita Festival at A'ala Park on O'ahu in 1971. (Courtesy of the Hawai'i State Archives.)

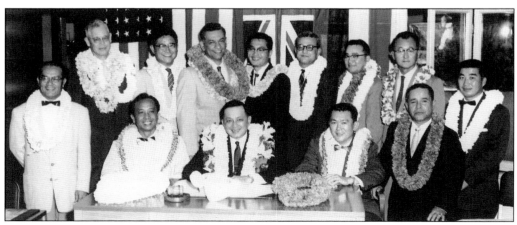

Richard I. Caldito Sr. (seated first from the left) was elected to the Maui County Council (pictured) from 1956 to 1972. He was the first American of Filipino ancestry to win a county council member's seat. (Courtesy of the Maui Historical Society.)

Educator and community activist Amy Agbayani (standing) is pictured here with Nancy Caraway, Ben Cayetano (standing), and Neil Abercrombie. The latter two were both members of the Hawai'i State Legislature in the 1970s and served as governors of the State of Hawai'i: Cayetano from 1994 to 2002 and Abercrombie in 2010. (Courtesy of Amy Agbayani.)

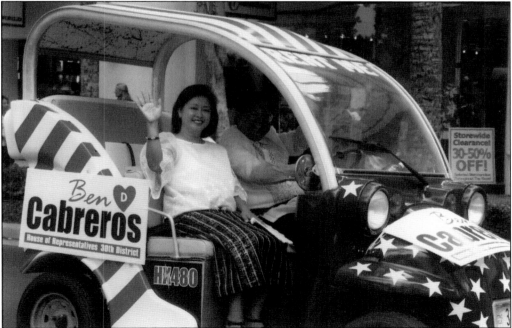

Ben Cabreros (right) represented the 30th district, which covers Moanalua, Kalihi Valley, and 'Ālewa, in the Hawai'i statehouse during the 20th and 21st legislatures from 1999 to 2002. (Courtesy of the Filipino Community Center.)

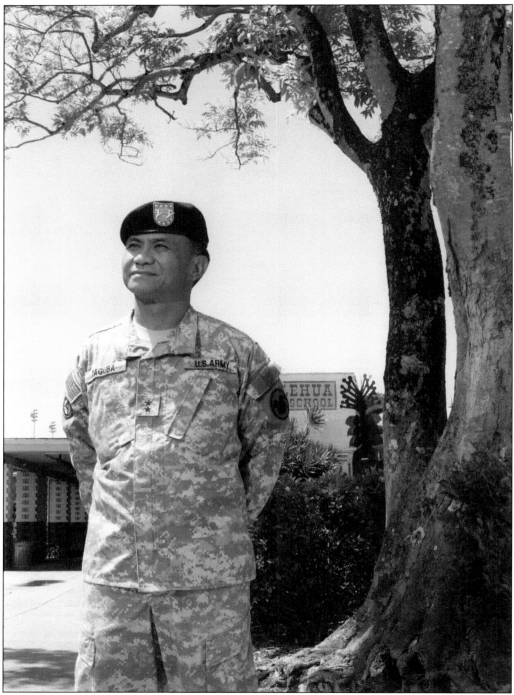

Maj. General Antonio Taguba (US Army, retired) authored the 2004 report about Iraqi prisoner abuse that took place at Abu Ghraib. Born in Sampaloc, Manila, in 1950, Taguba moved with his family to Hawai'i in 1961. He is pictured standing in front of Leilehua High School, Wahiawa, where he graduated in 1968. (Courtesy of Tim Llena.)

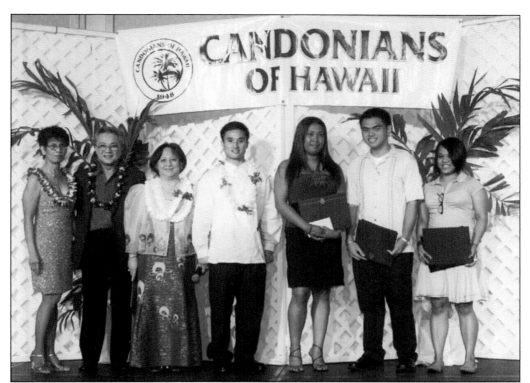

Filipino identities in Hawai'i are a complex mix of affiliations and affinities. Candon City, the trade capital of Ilocandia in the Philippines, is "Home of the World's Biggest Rice Cake and Tasty Chichacorn." Pampanga Circle of Hawai'i entered a parade float in the 2003 Filipino Fiesta and Parade in Waikiki. The lower half of the Pampanga Circle of Hawai'i seal reads, "Unity—Strength—Progress." Mount Arayat, at the center of the seal, is understood as a powerful symbol of strength in the region. (Both photographs courtesy of the *Fil-Am Courier.*)

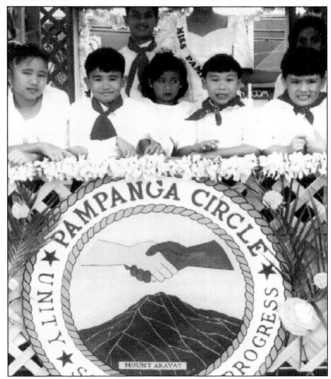

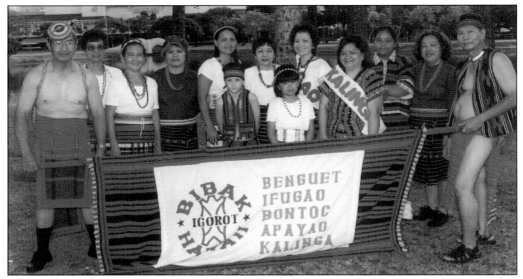

BIBAK Hawai'i promotes the various cultures of those who trace their ancestry to the Philippines' Central Cordillera of Northern Luzon. (Courtesy of the Filipino Community Center.)

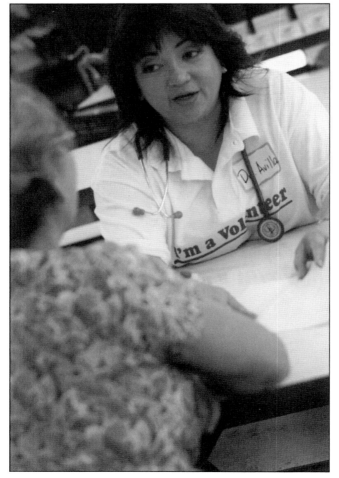

Medical missions rely on volunteers to provide local services such as dental or surgical clinics as well as overseas operations in the case of disasters or to provide specialized care in rural settings. (Courtesy of Tim Llena.)

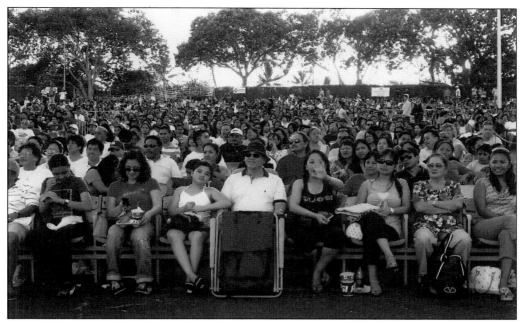

Filipino audiences are hard to please. This one at the Waikiki Shell waits for the GMA PinoyTV "Great Pacific Party" concert to begin in 2006. (Courtesy of *the Fil-Am Courier.*)

Based in Kaneohe, Rose and Thomas Churma's Kalamansi Books has helped satisfy the reading community that is interested in books about Philippine and Filipino American cultures. (Courtesy of Pepi Nieves.)

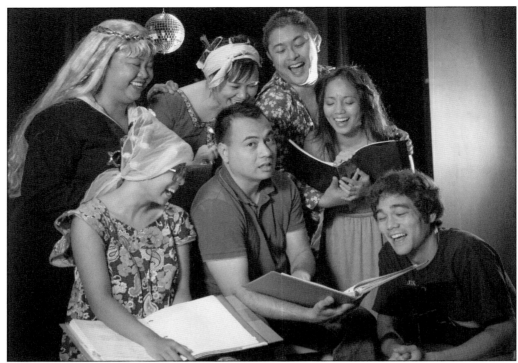

Writer R. Zamora Linmark appears with the Kumu Kahua Theatre cast that performed the theatrical version of a 1995 novel, *Rolling the R's*, about Filipino youth in Kalihi during the 1970s. Pictured from left to right are (bottom row) JaeDee Kay Vergara, R. Zamora Linmark, Maila Rondero, and Tyler Tanabe (kneeling); (top row) Malia Lagaso, Joy Lacanienta-Contreras, and M.J. Gonsalvo.

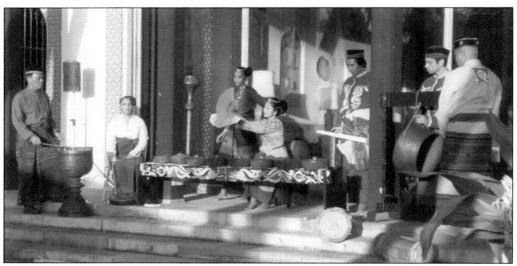

Bernard Ellorin (far right) leads the Mahalohalo Ensemble, a musical performance group anchored by the southern Philippine, ancient gong instrument, the *kulintang*. (Courtesy of Bernard Ellorin.)

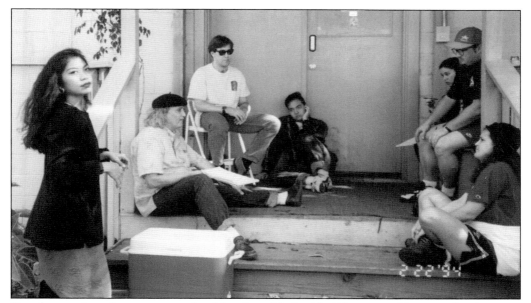

Broadcasters have kept an eye on local bands and helped build communities over the airwaves. During the 1990s, "Kathy with a K" worked at the listener-driven station Radio Free Hawai'i. Pictured from left to right are "Kathy with a K", Sheriff Norm Winter, Ken the Bone Machine Flynn, Shawn Speedy Lopes, Just Kai Han, DJ Daniel J, and Jennifer Winter on the "Sledgehammer" steps of RFH's Waipahu studio. (Courtesy of Kathy Libarios.)

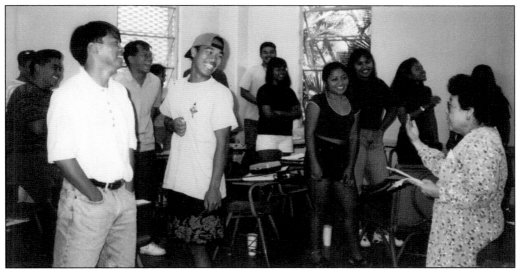

Every classroom becomes an opportunity to develop a temporary community of critical thinkers, listeners, and readers. No one knows this better than Teresita Ramos. When asked what this photograph was about, she replied, "I must have been teaching my class a song because they are all laughing at me." (Courtesy of Teresita Ramos.)

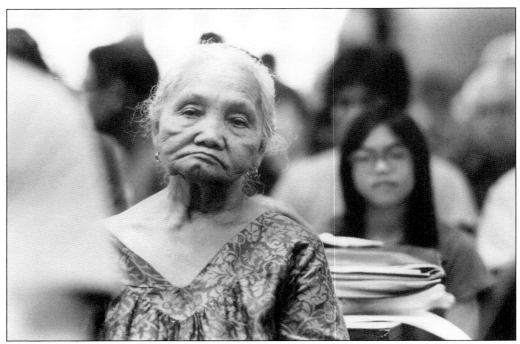

Epipania Estioko (above) is the mother of activist Jo Patacsil (not pictured). Together, they rallied residents and community activists in several anti-eviction campaigns throughout the 1980s. These two photographs demonstrate what community building sometimes entails: the patience to learn and listen to each other, and the need to pay forward to the next generation the experience and wisdom of political activity. (Both, courtesy of Ed Greevy.)

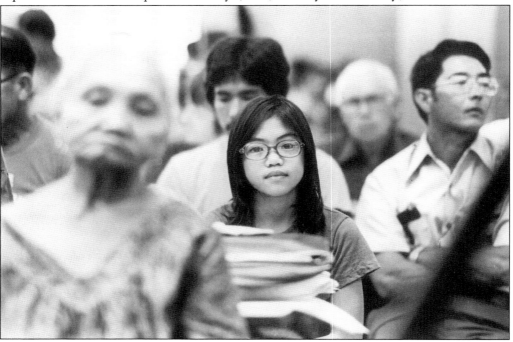

Six

SOCIAL MOVEMENTS

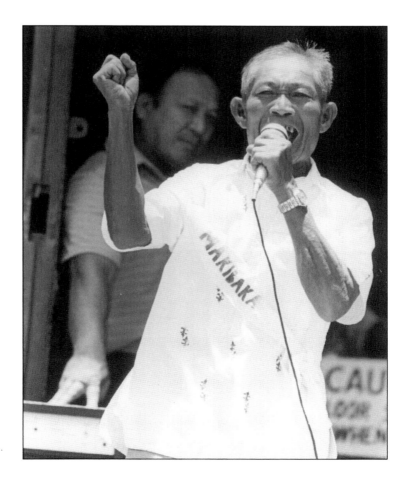

The text across this speaker's chest reads *Makibaka*, which means "dare to struggle." (Courtesy of Ed Greevy.)

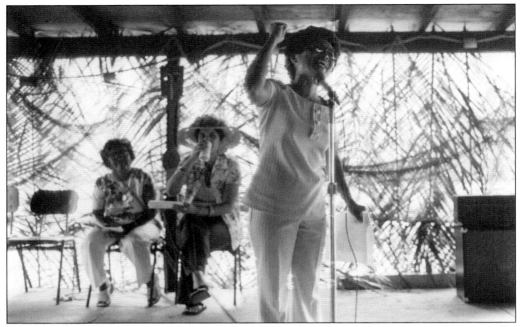

Josephine Patacsil, a resident of the windward side of O'ahu, connected struggles across the neighbor islands. Here, she speaks to a group at a Kaua'i rally in 1975. (Courtesy of Ed Greevy.)

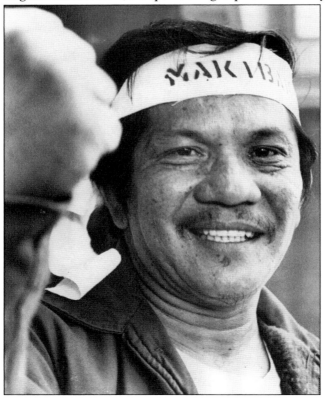

Pete Tagalog played a pivotal leadership role in organizing the residents of Ota Camp, also known as Makibaka Village. (Photograph by Albert Yamaguchi; courtesy of eFil: Filipino Digital Archives and History Center of Hawai'i.)

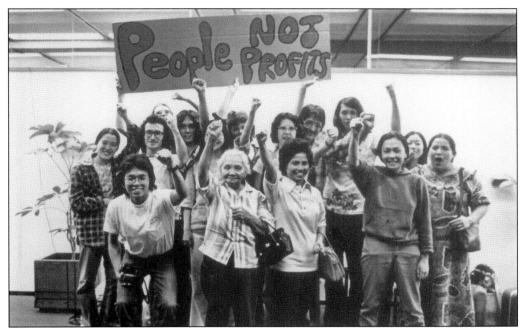

Hawai'i's real estate developers are remembered as innovators and pioneers. What about those who resisted unchecked development and overgrowth of the landscape? Pictured here is a group led by Epipania Estioko and her daughter Josephine Patacsil who celebrated the small victory of being able to, after a three-day vigil, meet with a real estate executive who wanted to build high-rise condominiums on Kaneohe's meadowlands. (Courtesy of Ed Greevy.)

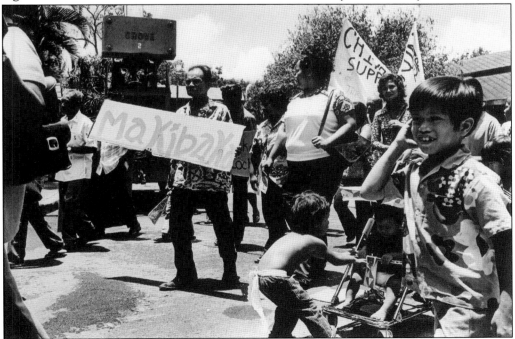

A community mobilizes for a rally. (Courtesy of Ed Greevy.)

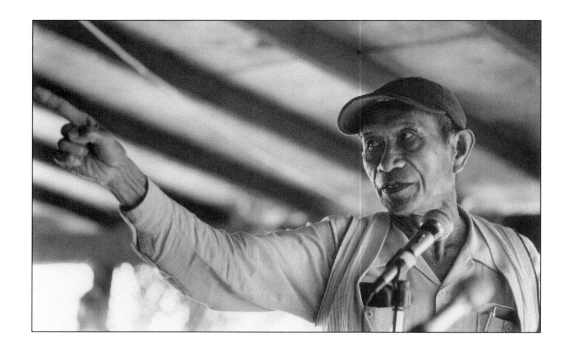

Photojournalist Ed Greevy was surprised by Mr. Obra's dynamism. At first, the speaker was unassuming, but he soon delivered impassioned testimony during this political rally on Kaua'i in 1975 (Courtesy of Ed Greevy.)

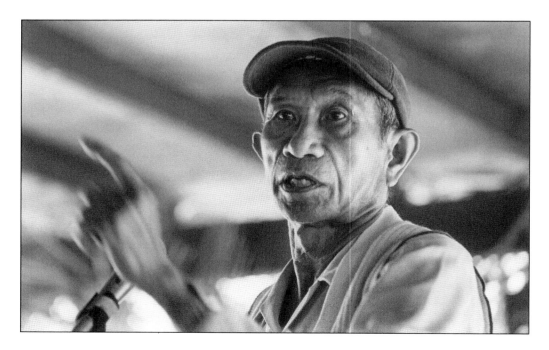

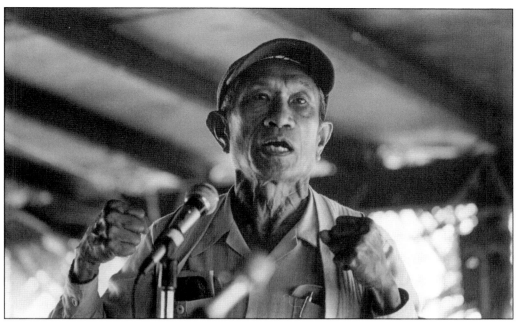

Mr. Obra addresses speaks out at a rally at Kaua'i in 1975. (Courtesy of Ed Greevy.)

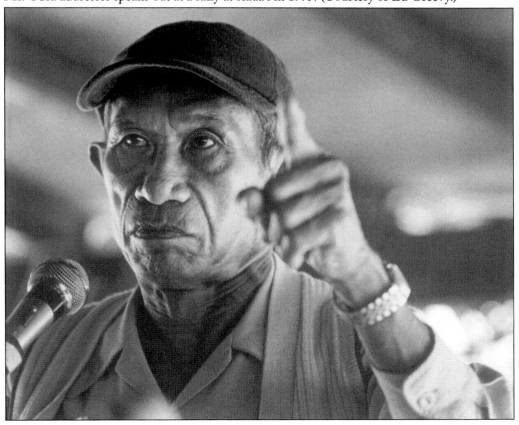

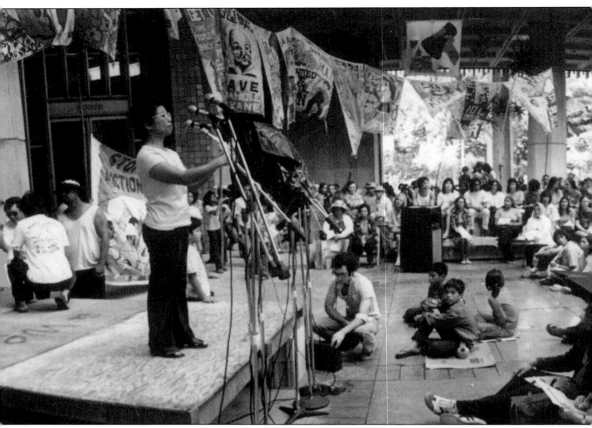

Notice the image of the upheld poi pounder (a symbol of resistance) hanging high above the

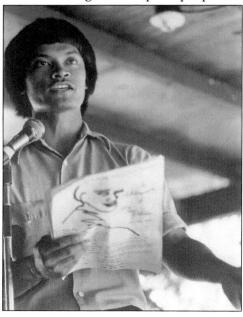

Vergillio Demain speaks at a Kaua'i rally in 1975. (Courtesy of Ed Greevy.)

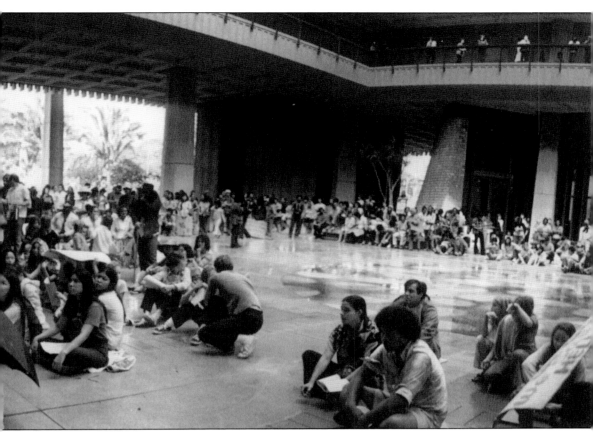

other banners at this anti-eviction rally at the Hawai'i State Capitol. (Courtesy of Ed Greevy.)

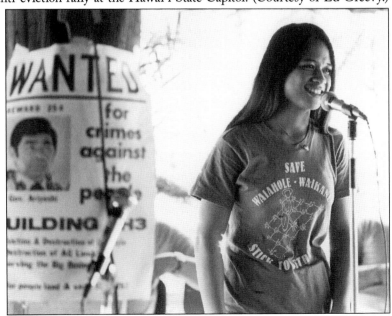

Zadia Manalo
addresses the crowd
at a Kaua'i rally in
1975. (Courtesy of
Ed Greevy.)

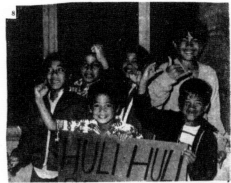

declaration

WE LOCAL PEOPLE have produced great wealth through our labor– on the plantations, in the canneries and now in tourism. But who profits from our hard work?

Not us! We live doubled up with relatives, in scrubby housing projects, even on the beaches. We pay the highest rents, mortgages, food prices and taxes in the country. We must work at two or more jobs and still have to worry about how to support our families.

We are forced to play servants for life – to feed the tourists, serve their *mai tais*, wash their dirty linen and bare our bodies to serve their appetites.

We cannot afford to live in the houses and hotels we build. We cannot afford the food we serve the tourists nor to own the land we till. We cannot take part in the decisions that rule our lives and our kids' lives

WERE DOES ALL THE WEALTH GO? It goes into the pockets of a handful of developers, landholders, tourist operators and politicians who sit back, make the decisions about our future and pocket the fruits of our labor. Yet without us, there would be no sugar, no pines, no tourism – NO NOTHING!

WHY ALL THIS? Our land and our labor were and are being stolen – that's why. Ninety percent of Hawaii's land is 'owned' by 72 landholders! Everybody knows they stole it through trickery and deception and by force and violence in 1893.

 KOKUA HAWAII

Huli is Hawaiian for REVOLUTION.

HULI
AGAINST THE HAOLES!

Kalayaan, a San Francisco-based community movement newspaper, featured a 1971 interview with Hawai'i residents Mateo Catania, Juffelia Ibarra, and Sheilah Kelly in conversation with Joaquin Dupio about connecting issues that affected Filipinos in Hawai'i, the continental United States, and the Philippines. (Courtesy of Theodore S. Gonzalves.)

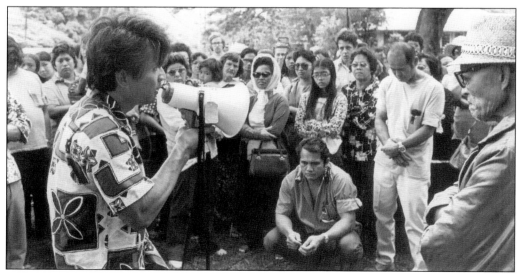

Ike Manalo speaks during a political sum-up after a circuit court demonstration. (Courtesy of Ed Greevy.)

Seven

PLAY

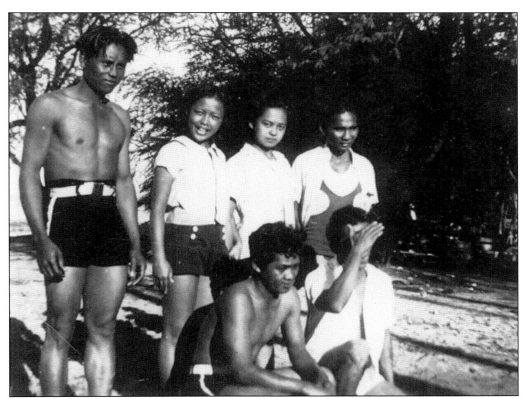

It is a beautiful day for a picnic at Kawaihae Beach on Kaua'i. (Courtesy of Ernest Libarios.)

Trudy Amano enjoys the day in Paauilo, Hawai'i, in this early-1950s photograph. (Courtesy of Ernest Libarios.)

These young boys are spending the day at Kā'anapali Beach on Maui. (Courtesy of Ernest Libarios.)

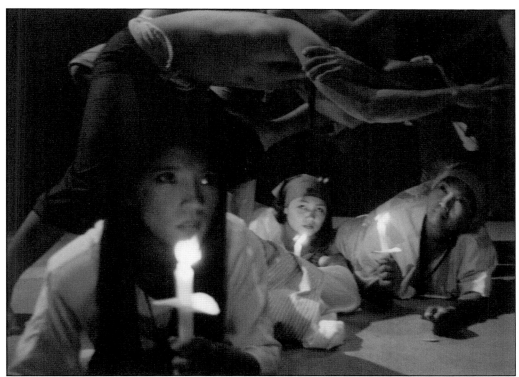

This image depicts a scene of an initiation ritual of new insurrectionists in Kumu Kahua's *PeregriNasyon* (Wandering Nation), a play written by Chris Millado. Actors pictured from left to right are Liberty Lemmo, Mary Axthelm, and Precy Espiritu. (Photograph by Jo Scheder; courtesy of Kumu Kahua Theatre.)

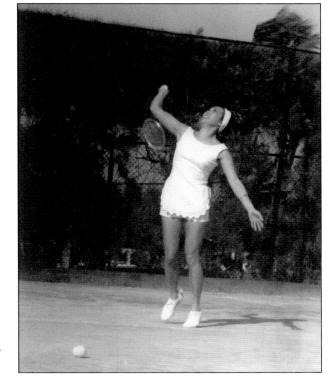

Joy Abbott (née Valderrama) won the Hawai'i Junior Tennis Tournament and competed in the nationals in Philadelphia, where she was an undergraduate at Temple University. (Courtesy of Domingo Los Baños.)

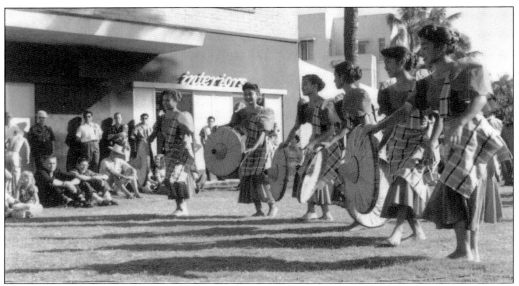

Dancers perform outside at the 1962 Filipino Fiesta at Ala Moana Park on Oʻahu. (Courtesy of the Hawaiʻi State Archives.)

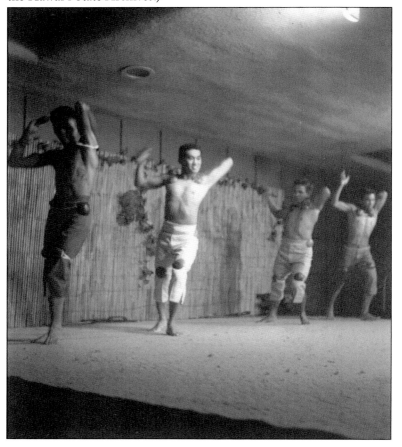

Indoors, dancers synchronize a groove during *maglalatik*, a cultural dance where coconut shell halves are used. (Courtesy of the Hawaiʻi State Archives.)

It is proper to put a drink down when dancing, but not during the performance of the *binasuan*, which means "with the use of drinking glasses." (Courtesy of the Hawai'i State Archives.)

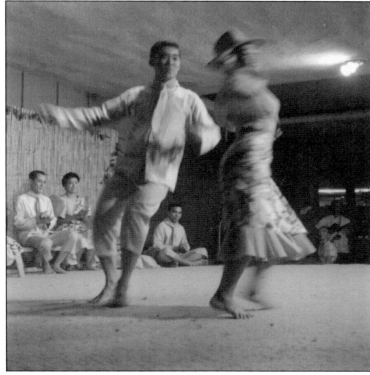

A couple takes center stage during a Philippine folkloric dance. (Courtesy of the Hawai'i State Archives.)

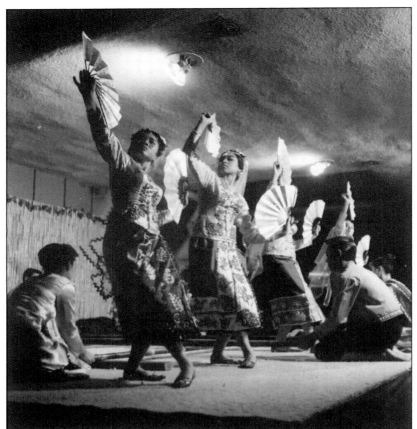

This ensemble performs the *singkil* dance from the Maranao region of the southern Philippines. (Courtesy of the Hawai'i State Archives.)

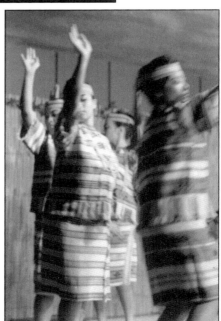

Dancers perform at the 1962 Filipino Fiesta at Ala Moana Park on O'ahu. (Courtesy of the Hawai'i State Archives.)

In the Philippines, folk dance was introduced into the curriculum in the 1930s by physical education instructors who were trained at YMCA colleges in the United States. In this photograph, dancers perform at the 1962 Filipino Fiesta. (Courtesy of the Hawai'i State Archives.)

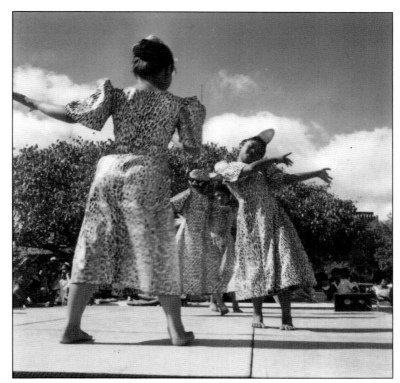

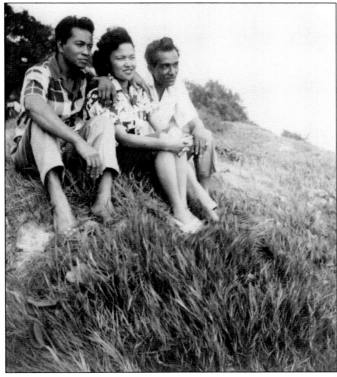

A trio looks toward the shoreline. (Courtesy of Tasha Valenzuela.)

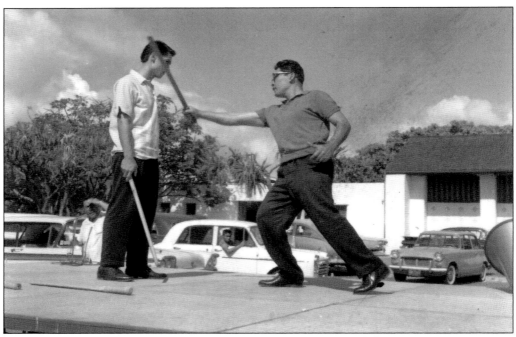

Two men spar in a demonstration of Philippine martial arts, called *eskrima, arnis* or *kali*, at the Filipino Fiesta at Ala Moana Park on Oʻahu in 1962. (Both, courtesy of the Hawaiʻi State Archives.)

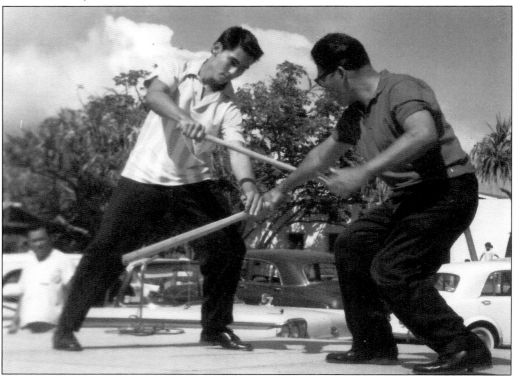

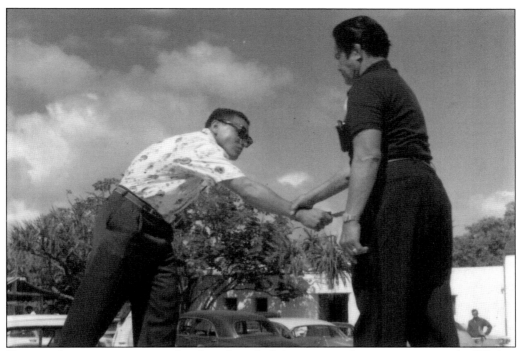

This pair demonstrates an open-hand version of *eskrima*, *panuntukan*, or *pangamot* at the Filipino Fiesta. (Both, courtesy of the Hawai'i State Archives.)

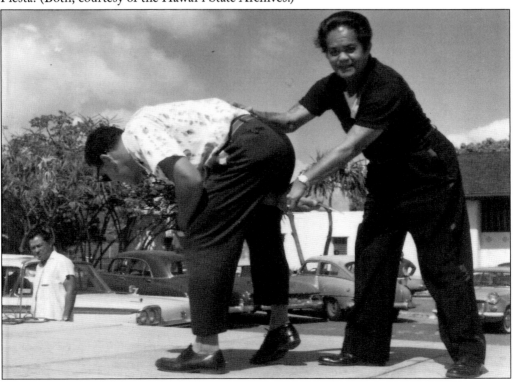

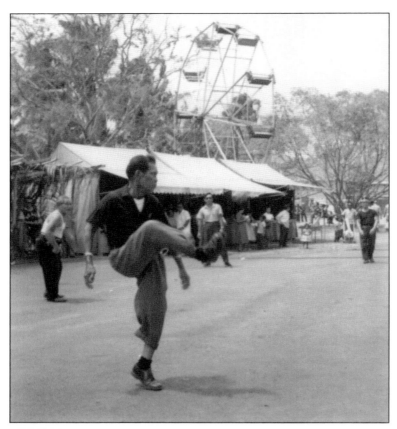

Veteran *sipa* players prevent the kicked object, which could be a rattan ball or metal washers wrapped in cloth, from landing on the ground at Filipino Fiesta at Ala Moana Park on Oʻahu in 1962. (Courtesy of the Hawaiʻi State Archives.)

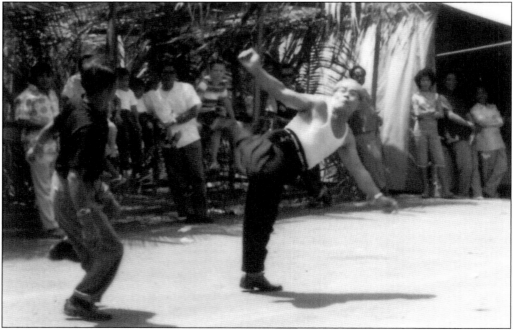

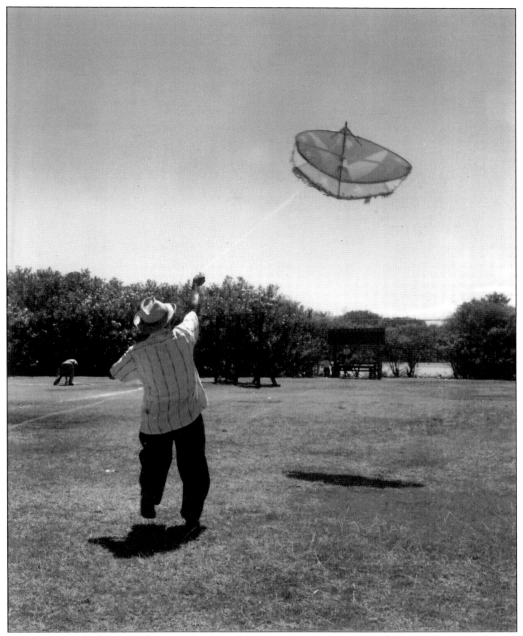

Kite makers like Patricio Gongob have perfected tailless designs with the use of bamboo frames and plastic sheeting. Here, a kite runner sails his craft above the park's trees during the Filipino Fiesta at Ala Moana Park on Oʻahu in 1962. (Courtesy of the Hawaiʻi State Archives.)

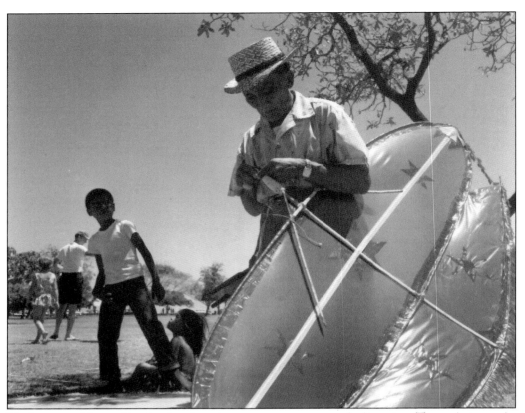

The lesson on kite making begins though not everyone seems to be listening. These photographs was taken during the Filipino Fiesta at Ala Moana Park in Oʻahu in 1962. (Both, courtesy of the Hawaiʻi State Archives.)

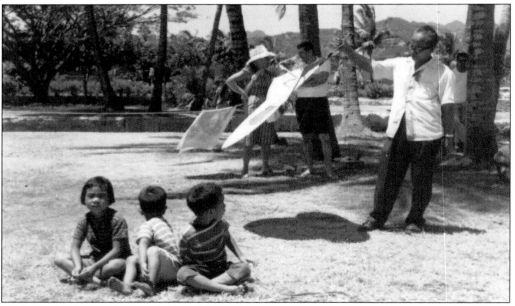

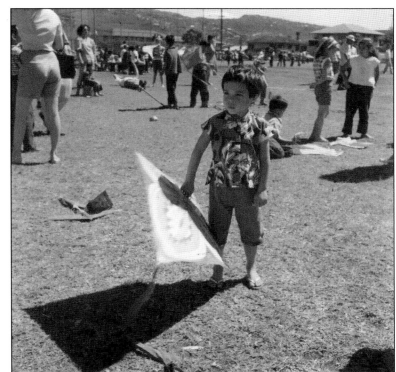

In these photographs, two young kite runners take their crafts to the field. (Both, courtesy of the Hawai'i State Archives.)

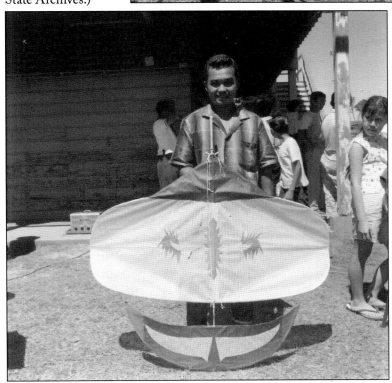

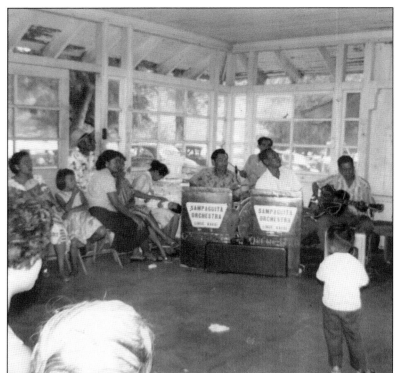

Pictured here is the Sampaguita Orchestra of Lihue on Kaua'i providing entertainment. In Hawai'i, the *sampaguita* flower is known as *pikake*. (Courtesy of Tasha Valenzuela.)

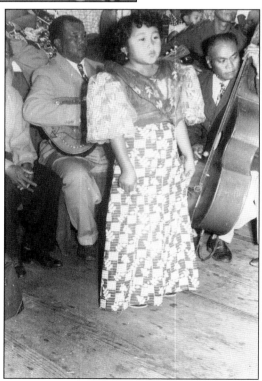

Eight-year-old Pauly Quanon sings at a gathering in Kona, Hawai'i, in this c. 1940s photograph. (Courtesy Ernest Libarios.)

Drummers are standing ready during the 2006 Ati-Atihan Santo Niño Festival in Honolulu, Hawai'i. (Courtesy of Theodore S. Gonzalves).

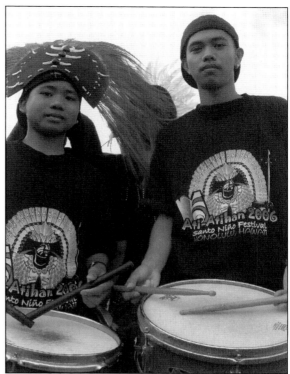

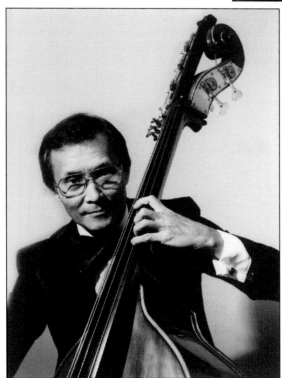

Angel Peña played the bass violin and served as arranger for the Honolulu Symphony Orchestra between 1969 and 1997. Like many working musicians, Peña traveled throughout Asia and worked with some of the world's best musicians, including Thelonious Monk and Herbie Mann. (Courtesy of Angel Peña.)

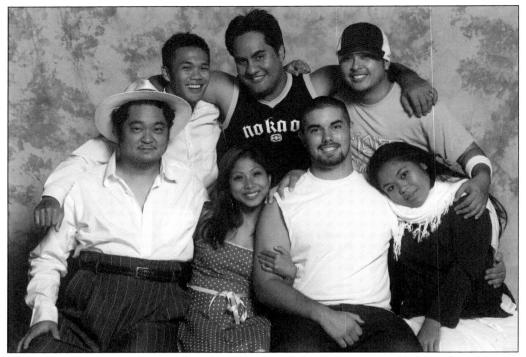

Playwright Troy Apostol wrote the play *Who the Fil Am I?* for younger Filipino Americans in Hawai'i, a generation that is "starving for identity in a world that forces stereotypes on them." Kumu Kahua Theatre, where the production was mounted, produces plays about life in Hawai'i, plays by Hawai'i's playwrights, and plays for Hawai'i's people. The cast, pictured clockwise from the left, is Stu Hirayama, Cheyne Gallarde, Reno David, M.J. Gonzalvo, Kiana Rivera, K.C. Odell, and Jaedee-Kae Vergara. (Photograph by Brad Goda; courtesy of Kumu Kahua Theatre.)

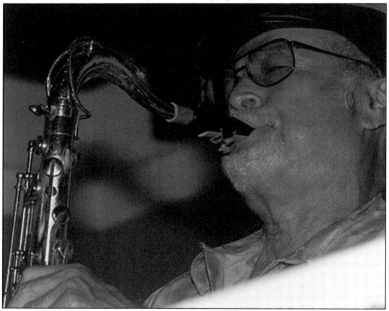

With a professional career in jazz that spans six decades, multi-reed instrumentalist Gabriel "Gabe" Baltazar Jr. is perhaps one of the most-respected musicians from Hawai'i with numerous recording credits to his name. He is also a member of Stan Kenton's powerful touring jazz orchestra. (Courtesy of Theo Garneau.)

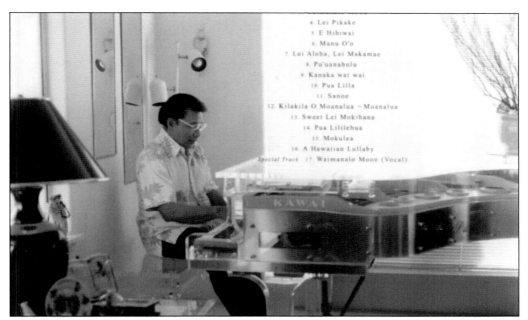

4. Lei Pikake
5. E Hihiwai
6. Manu O'o
7. Lei Aloha, Lei Makamae
8. Pu'uanahulu
9. Kanaka wai wai
10. Pua Lilla
11. Sanoe
12. Kilakila O Moanalua ~ Moanalua
13. Sweet Lei Mokihana
14. Pua Lililehua
15. Mokulea
16. A Hawaiian Lullaby
Special Track 17. Waimanalo Moon (Vocal)

With a strong technical command of his instrument, Rene Paulo's career blossomed in the era where tourism, jazz, and a cosmopolitan sound took hold in Honolulu nightclubs of the 1950s and 1960s. Here, the maestro performs on a transparent piano. The image is used for the tray card of Paulo's album *Waimanalo Moon*. (Photograph courtesy of Kenichi Takahashi.)

Friends relax while one strums a ukulele in Ewa Plantation Village in 1975. (Courtesy of the Hawaiian Collection, University of Hawai'i at Mānoa Library.)

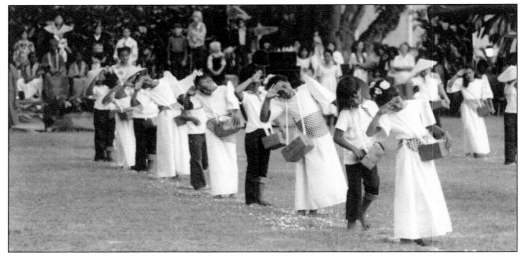

Second- and third-grade students of the Mililani Uka Elementary School perform on Oʻahu in 1978. (Courtesy of Domingo Los Baños.)

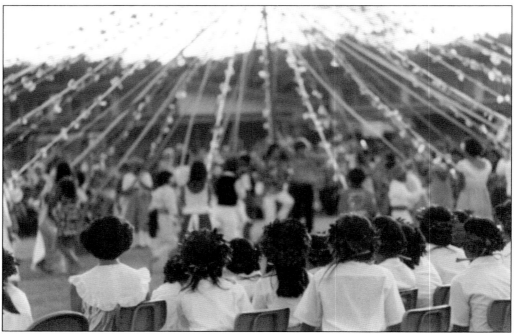

Students from the Haleʻiwa Elementary School watch their classmates perform on Oʻahu in 1978. (Courtesy of Domingo Los Baños.)

Eight

MARIO BAUTISTA

Mario Ponciano Bautista was born in 1917 and raised in Caloocan, Philippines. The second eldest of 12 siblings, his father's family comes from Cavite City and his mother's from Tacloban City, Leyte. After receiving his medical degree at the University of Santo Tomas in 1943, he volunteered as a US Army medic. Bautista was then hired to staff the Wettengel dispensary on Guam, pictured here in 1949. For the complete narrative, visit the website FilipinosInHawaii. info. (Courtesy of Clement C. Bautista.)

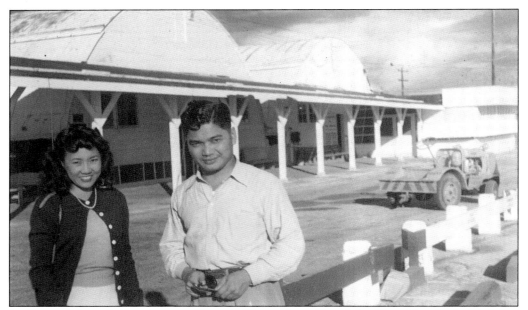

In Guam, Mario P. Bautista met Eugenia Young from Honolulu, Hawai'i, who had left her family's poultry farm to work as a civilian with the US Army Corps of Engineers. Eugenia was able to travel to Manila in 1948 and became familiar with the devastation caused by the war. Mario courted Eugenia, who was one of the few single women on base. He followed her to Hawai'i to meet her family. (Courtesy of Clement C. Bautista.)

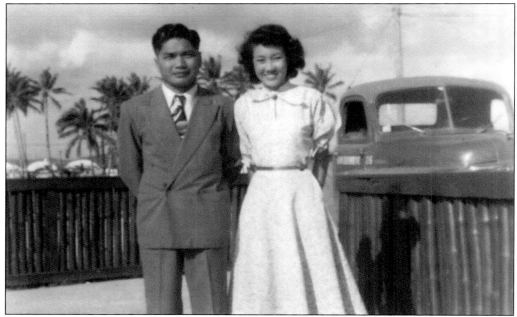

Eugenia encouraged Mario to learn a medical specialization. He settled on obstetrics and gynecology (OB/GYN) as a specialty. Young advised him to study at the University of Chicago's Lying-In Hospital. He bade farewell to the Young family and traveled to Chicago for his studies and to prepare the way for Eugenia to follow. (Courtesy of Clement C. Bautista.)

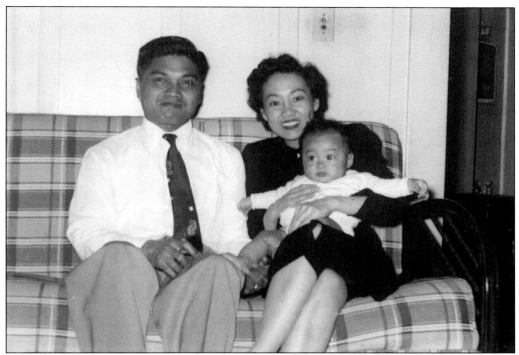

Mario arrived in Chicago but was too late to apply for a position. He would have to wait another year. Mario's interviewer said he could work as an orderly in the meantime while staying in an empty room at the hospital and continuing his training. Mario and Eugenia's first son, Frederick, was born in Chicago's Lying-In Hospital. (Courtesy of Clement C. Bautista.)

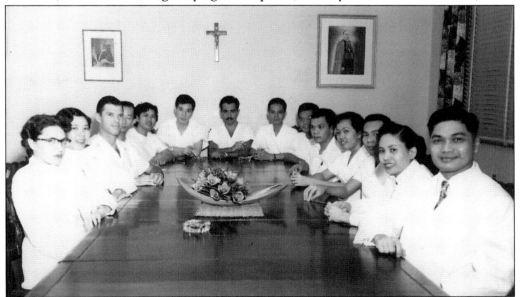

After the 2.5-year training period, the family moved back to Honolulu, and Mario was immediately hired to be the chief OB/GYN resident at St. Francis Hospital in Nuuanu. (Courtesy of Clement C. Bautista.)

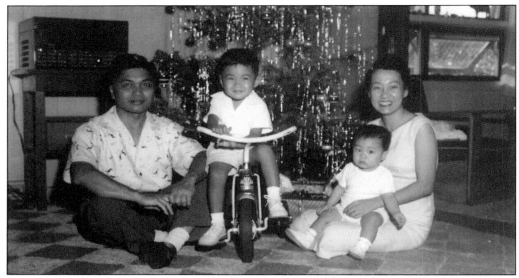

A year later, Mario was promoted to chief resident at Kapiolani Maternity Hospital. The family, now with a second son, lived in the chief resident's house located on the hospital grounds. (Courtesy of Clement C. Bautista.)

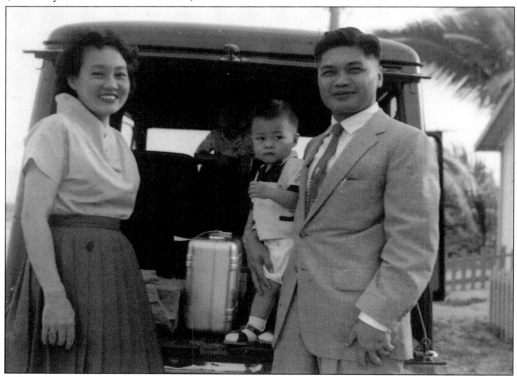

Mario took a break from work in order to prepare for his state board license. The family moved to Canton Island (or Kanton Island), a military and commercial refueling atoll among the Kiribati Islands, where Mario would have the time to study and still collect an income as the island's medical officer. (Courtesy of Clement C. Bautista.)

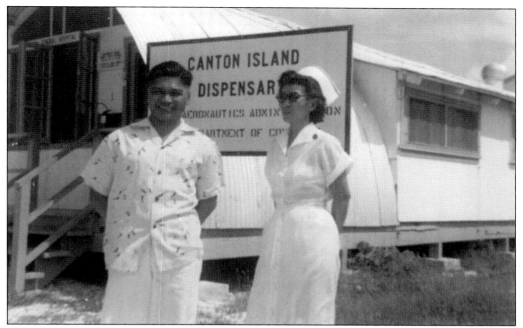

Mario is pictured here with a nurse outside of the Canton Island dispensary at the Civil Aeronautics Administration in 1957. (Courtesy of Clement C. Bautista.)

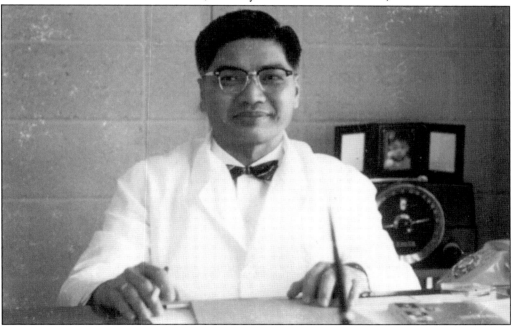

In 1958, Mario passed the licensing board exam, became a citizen, and joined the newly built Kaiser Hospital as one of a new core of physicians joined together in, at the time, a revolutionary, prepaid medical delivery system. The Kaiser plan was so innovative that the first baby born in the new hospital, who was delivered by Mario, made the news. Mario eventually left Kaiser to set up his own private practice. (Courtesy of Clement C. Bautista.)

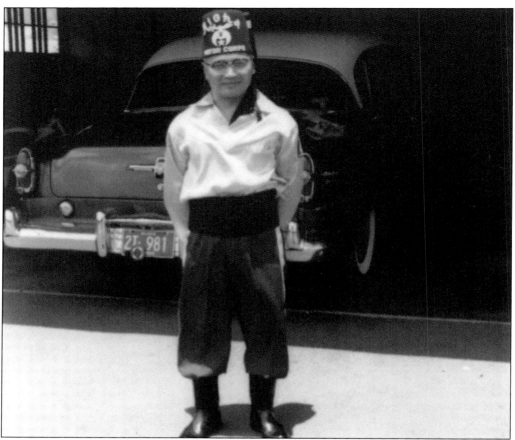

Mario was a member of the Grand Lodge of Free and Accepted Masons of the Philippine Islands, was president of the United Filipino Council of Hawai'i (1971), and was active in the larger community as well. In 1969, he was a member of the US Army Friendship Mission, a diplomatic and goodwill delegation to the Philippines representing the United States. (Courtesy of Clement C. Bautista.)

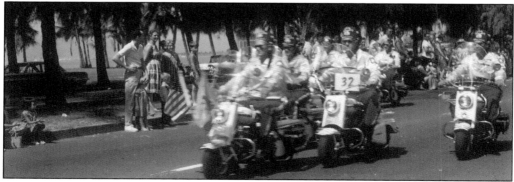

Mario was also active with the Kiwanis Club of Waikiki and the Aloha Shriners motor corps. Additionally, he served as a board member of Mayor Frank Fasi's board of parks and recreation and the Friends of the East-West Center, serving as a clinic training physician with the University of Hawai'i John A. Burns School of Medicine. (Courtesy of Clement C. Bautista.)

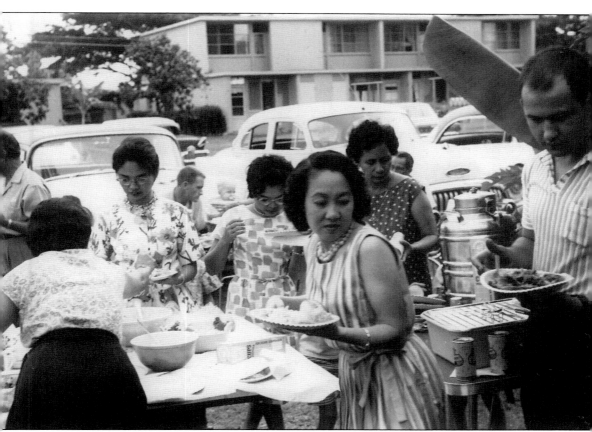

In this photograph, Eugenia (front) is at a family gathering in the naval housing unit along with Mario's sisters Antonia and Rica, who both wore glasses in this c. 1960 photograph. (Courtesy of Clement C. Bautista.)

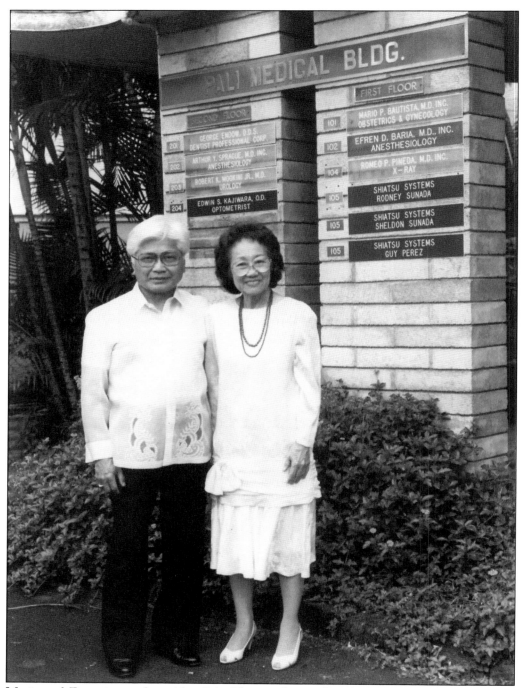

Mario and Eugenia stand outside of the Nuuanu Street clinic before attending the wedding of a formerly employed nurse in 1986. Mario Ponciano Bautista died on January 28, 1994. Operating room nurses remember him as always smiling. In the end, he was the only doctor who remained in the operating room post-op to help clean up and restore the operating room to its original pristine state. (Courtesy of Clement C. Bautista.)

Nine

AMEFIL "AMY" AGBAYANI

Amefil "Amy" Agbayani is pictured here during her college years at the University of the Philippines at Diliman. Born in the Philippines during World War II, her first name was created by her father to acknowledge the common struggle of the United States and the Philippines. (Courtesy of Amy Agbayani.)

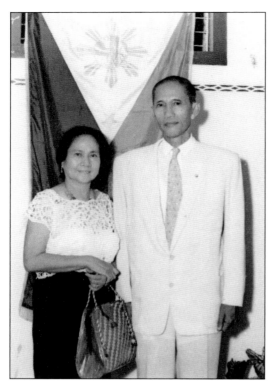

Amy's mother, Remedios Macaranas, was a teacher and her father, Adeudato Agbayani, was a journalist and college teacher. After the Philippines's independence, Adeudato was part of the first cohort of Filipino diplomats assigned to Australia from 1947 to 1948. Remedios became active in community affairs. The family stayed in Australia for nine years. This photograph was taken in Sydney. (Courtesy of Amy Agbayani.)

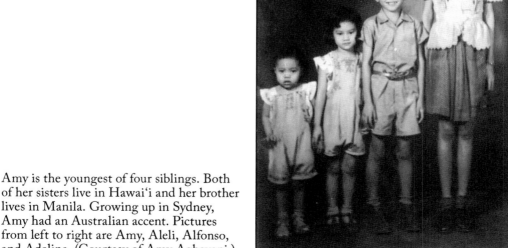

Amy is the youngest of four siblings. Both of her sisters live in Hawai'i and her brother lives in Manila. Growing up in Sydney, Amy had an Australian accent. Pictures from left to right are Amy, Aleli, Alfonso, and Adelina. (Courtesy of Amy Agbayani.)

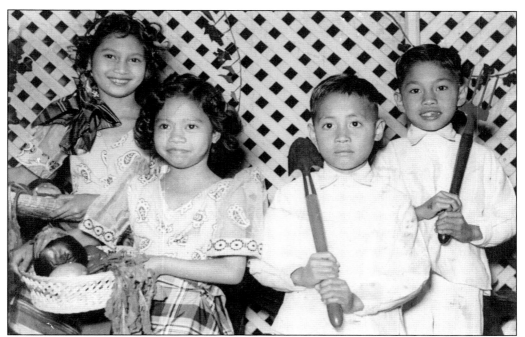

Amy is pictured second from the left. Her sister Aleli is to the far left. The two boys were also the children of diplomats. Growing up in Sydney, the youngsters often performed during Filipino cultural events. (Courtesy of Amy Agbayani.)

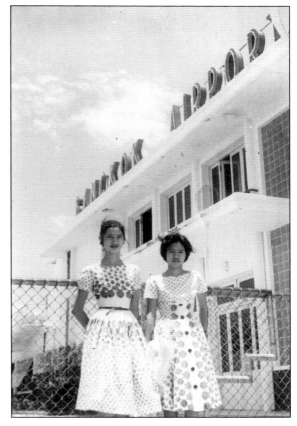

Amy (right) is photographed at the Bangkok airport. Her father's second diplomatic post was in Thailand, which was where Amy attended high school. (Courtesy of Amy Agbayani.)

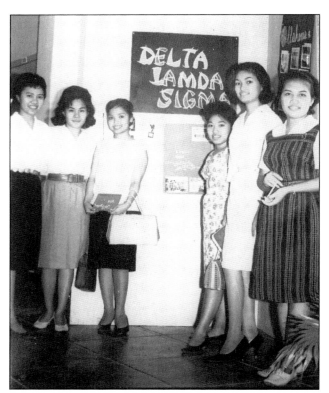

During her undergraduate years at the University of the Philippines, Amy (far left) joined a sorority, the political science club, and was a member of student government. (Courtesy of Amy Agbayani.)

In this photograph, Amy (kneeling, right) is seen with family members after they arrived from Australia. Her parents were en route to their second diplomatic post in Thailand. (Courtesy of Amy Agbayani.)

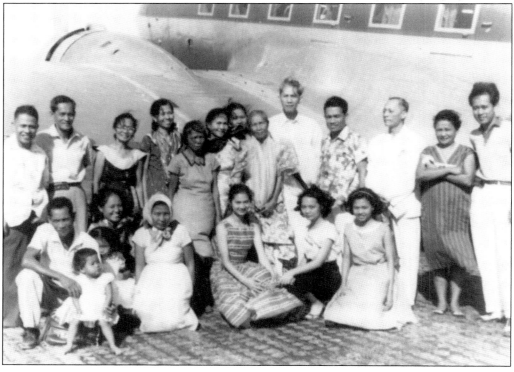

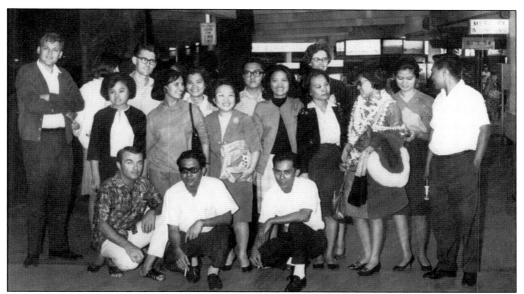

As a grant recipient of the East-West Center in 1964, Amy began work on her master's and doctoral work at the University of Hawai'i at Mānoa. In this 1965 photograph, she has just arrived from a field trip to Cornell and Washington, DC, to do her master's research. Her dissertation in political science, completed in 1969, focused on black students' participation in the civil rights movement. (Courtesy of Amy Agbayani.)

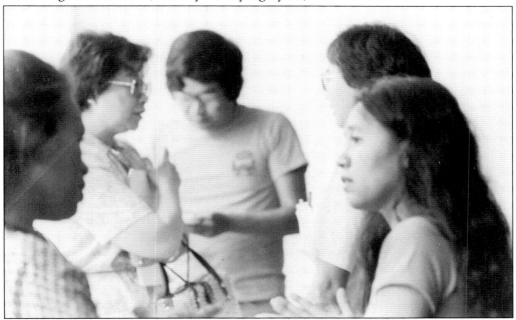

Amy completed her doctoral degree at the age of 26, and her first job was to work in Kalihi-Pālama on a model cities program. Her political- and community-based work deepened. This photograph depicts Amy working with an interagency council for immigrants. Many of the issues that she and others worked on included bilingual education efforts to assist newly arrived immigrant children. (Courtesy of Amy Agbayani.)

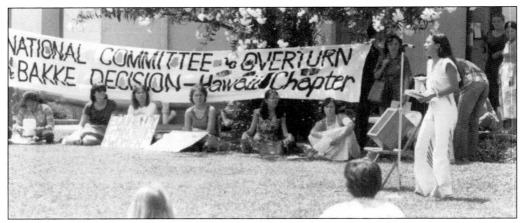

Amy is photographed during a rally outside of the federal building addressing minorities and access to higher education. Along with Sheila Forman and Melinda Kerkvliet, Amy founded Operation Manong, a project that eventually widened to address educational inequalities among other immigrant communities. Amy became active in campaigns to end the Vietnam War as well as protested Ferdinand Marcos's martial law regime. (Courtesy of Amy Agbayani.)

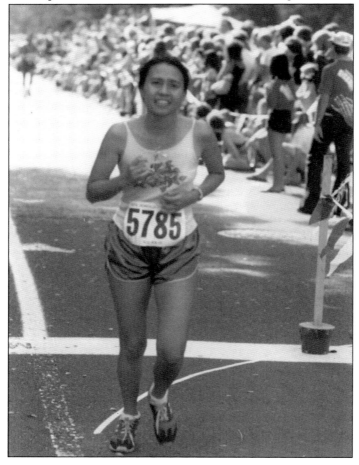

Amy has run four marathons. This photograph was taken during her first race. (Courtesy of Amy Agbayani.)

The three Agbayani sisters live in Honolulu. Pictured from left to right are Amy, Adelina, and Aleli. (Courtesy of Amy Agbayani.)

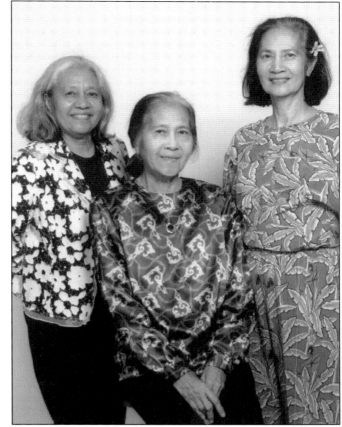

Amy attends the signing of a new civil rights law by Gov. John D. Waihee III, who was in office from 1986 to 1994. The law established the Hawai'i Civil Rights Commission, and Amy became its first chairperson, a position she held for eight years. (Courtesy of Amy Agbayani.)

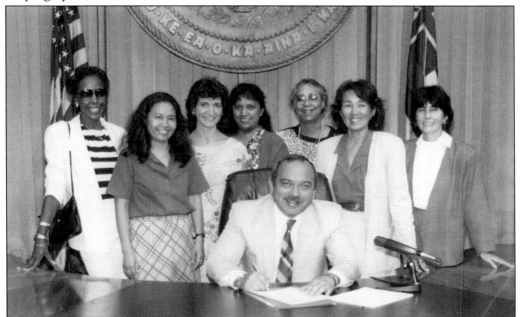

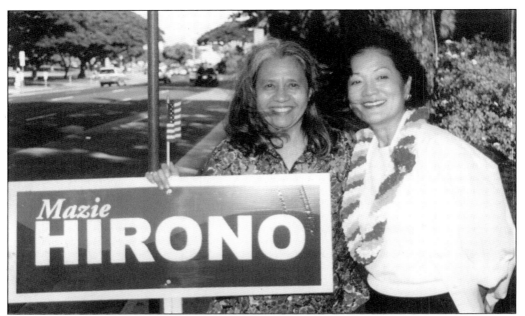

Mazie Hirono was the ninth lieutenant governor of the State of Hawai'i. In this photograph, Amy joined Hirono's campaign for governor in 2002. (Courtesy of Amy Agbayani.)

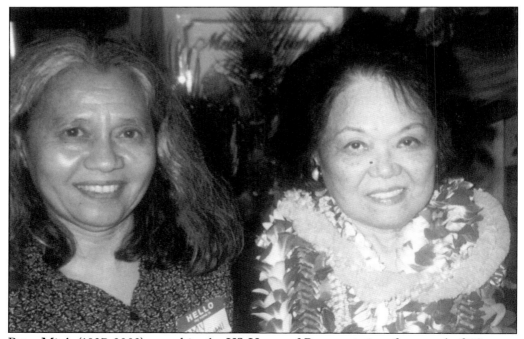

Patsy Mink (1927–2002) served in the US House of Representatives for a total of 12 terms and was the author of the Title IX Amendment of the Higher Education Act. (Courtesy of Amy Agbayani.)

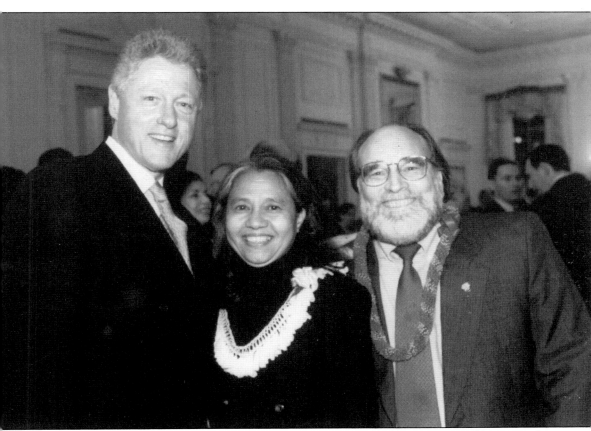

Amy attends a reception at the White House and is pictured with Pres. Bill Clinton and Congressman Neil Abercrombie. (Courtesy of Amy Agbayani.)

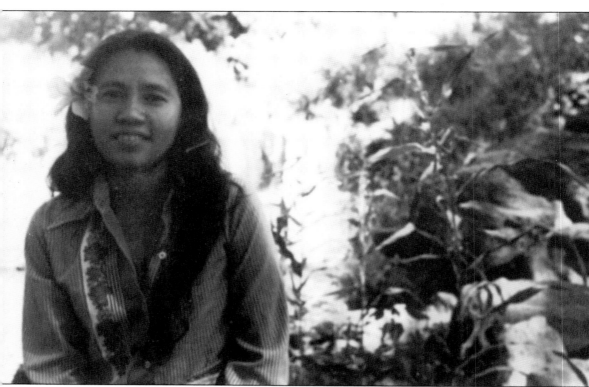

In a 2010 interview that was broadcast on local public television, journalist Leslie Wilcox asked Amy, "I think it takes sort of a fire to continue to do what you do. What keeps it burning?" Amy replied, "I make no boundaries between my work, my community work, or my professional career. I get rewarded for doing these things, so it's not really hard for me to do this." (Courtesy of Amy Agbayani.)

BIBLIOGRAPHY

Anderson, Robert N. *Filipinos in Rural Hawai'i*. Honolulu, HI: University of Hawai'i Press, 1984.

Beechert, Edward D. *Working in Hawai'i: A Labor History*. Honolulu, HI: University of Hawai'i Press, 1985.

Dorita, Mary. *Filipino Immigration to Hawai'i*. San Francisco, CA: R and E Research Associates, 1975.

Fujikane, Candace, and Jonathan Y. Okamura, eds. *Asian Settler Colonialism: From Local Governance to the Habits of Everyday Life in Hawai'i*. Honolulu, HI: University of Hawai'i Press, 2008.

Jung, Moon-Kie. *Reworking Race: The Making of Hawai'i's Interracial Labor Movement*. New York, NY: Columbia University Press, 2006.

Kerkvliet, Melinda Tria. *Unbending Cane: Pablo Manlapit, a Filipino Labor Leader in Hawai'i*. Honolulu, HI: Office of Multicultural Student Services, University of Hawai'i at Mānoa, 2002.

Lasker, Bruno. *Filipino Immigration to Continental United States and to Hawai'i*. Chicago, IL: University of Chicago Press, 1931.

Nieva, Pepi, ed. *Filipina: Hawai'i's Filipino Women*. Honolulu, HI: Filipino Association of University Women Publications, 1994.

Okamura, Jonathan Y. *Ethnicity and Inequality in Hawai'i*. Philadelphia, PA: Temple University Press, 2008.

Okamura, Jonathan Y., Amefil R. Agbayani, and Melinda Tria Kerkvliet, guest eds. "The Filipino American Experience in Hawai'i: In Commemoration of the 85th Anniversary of Filipino Immigration to Hawai'i." *Social Process in Hawai'i* 33 (1991).

Okamura, Jonathan Y., guest ed. "Filipino American History, Identity, and Community in Hawai'i, In Commemoration of the 90th Anniversary of Filipino Immigration to Hawai'i." *Social Process in Hawai'i* 37 (1996).

Raymundo, Angeles Monrayo. *Tomorrow's Memories: A Diary, 1924-1928*, edited by Rizalne R. Raymundo. Honolulu, HI: University of Hawai'i Press, 2003.

Reinecke, John E. *The Filipino Piecemeal Sugar Strike of 1924–1925*. Honolulu, HI: Social Science Research Institute, University of Hawai'i, 1996.

Takaki, Ronald T. *Pau Hana: Plantation Life and Labor in Hawai'i, 1835–1920*. Honolulu, HI: University of Hawai'i Press, 1983.

Teodoro, Luis V. Jr., ed. *Out of This Struggle: The Filipinos in Hawai'i*. Honolulu, HI: University of Hawai'i Press, 1981.

DISCOVER THOUSANDS OF LOCAL HISTORY BOOKS FEATURING MILLIONS OF VINTAGE IMAGES

Arcadia Publishing, the leading local history publisher in the United States, is committed to making history accessible and meaningful through publishing books that celebrate and preserve the heritage of America's people and places.

Find more books like this at
www.arcadiapublishing.com

Search for your hometown history, your old stomping grounds, and even your favorite sports team.

Consistent with our mission to preserve history on a local level, this book was printed in South Carolina on American-made paper and manufactured entirely in the United States. Products carrying the accredited Forest Stewardship Council (FSC) label are printed on 100 percent FSC-certified paper.

MADE IN THE USA